Reading and Teaching
the Postcolonial

Reading and Teaching the Postcolonial

FROM BALDWIN TO BASQUIAT AND BEYOND

GREG DIMITRIADIS
CAMERON McCARTHY

Foreword by
Maxine Greene

Teachers College, Columbia University
New York and London

Published by Teachers College Press, 1234 Amsterdam Avenue, New York, NY 10027

Authors' note: We would like to thank Jim Murray and the C. L. R. James Institute in New York City for access to Constance Webb's letters, as well as a tape of James Baldwin's 1983 lecture at Yale.

Credits:
Cover: *Notes to Basquiat: To Be Continued* by Gordon Bennett. Used with permission.
Figure 5.1: *The Outsider* by Gordon Bennett. Used with permission. Mr. Bennett is represented by the Sutton Gallery, Melbourne; Bellas Gallery, Brisbane; and Sherman Galleries, Sidney, Australia.
Figure 5.2: *Five Hundred Years without an Ear* by Arnaldo Roche-Rabell. From the collection of Mrs. Marie Hélène Morrow, Galería Botello, Hato Rey, Puerto Rico. Used with permission.

Library of Congress Cataloging-in-Publication Data

Dimitriadis, Greg, 1969–
 Reading and teaching the postcolonial : from Baldwin to Basquiat and beyond / Greg Dimitriadis, Cameron McCarthy ; foreword by Maxine Greene.
 p. cm.
 Includes bibliographical references (p.) and index.
 ISBN 0-8077-4152-3 (cloth : alk. paper) — ISBN 0-8077-4151-5 (pbk. : alk. paper)
 1. Arts—Study and teaching (Higher)—United States. 2. Postcolonialism and the arts—Study and teaching (Higher)—United States. I. McCarthy, Cameron. II. Title.

NX284.3 .D56 2001
700'.71—dc21 2001027729

ISBN 0-8077-4151-5 (paper)
ISBN 0-8077-4152-3 (cloth)

Printed on acid-free paper

Manufactured in the United States of America

08 07 06 05 04 03 02 01 8 7 6 5 4 3 2 1

Contents

Foreword

Breaking through familiar boundaries, *Reading and Teaching the Postcolonial* opens unexpected perspectives on education in a time of "globalization." Educators have become accustomed to notions of multiculturalism and diversity that focus on binary relations or dualities: majority/minority; White/Black; center/periphery; developed/underdeveloped. Greg Dimitriadis and Cameron McCarthy show how with the spread of media on a global scale, developments such as the Internet, and the mixing of popular cultures, there are interconnections and a new "hybridity" that pose new challenges to schools and the designers of curriculum. Given what they call novel "mediascapes," these challenges bring with them new pedagogical possibilities—at least for those willing to reflect on and in time break with customary habits of thought, including those that make so many defensive about canons and a one-dimensional traditions.

Using and clarifying the once estoric term, *postcolonialism*, they point to the dramatic changes in the way the once colonized have begun to view themselves and their past suffering. At once, the authors call on us in the once self-satisfied West to acknowledge the depth and complexity of intersecting histories and streams of thought. They suggest, for example, that we look through the lenses of African or Caribbean literatures to make new kinds of sense of what we treasure as our canon, the bearer of what has appeared essential to our identities.

Also as important and challenging is their use of various arts as sources of significant insight and understanding when it comes not only to the new diasporas and the once invisible cultures becoming visible, but also to the relation between past and present and between memory and "rememory." They bring to the fore certain writers with which we are familiar—James Baldwin, Derek Walcott, and Toni Morrison, for example—and objecting to the customary split between the verbal and visual arts, they introduce the paintings of Jean-Michel Basquiat (already

known for his hybrid heritage, his sensitivity to the worlds of ideas) as well as to popular music and dance, to graffiti, and to drawing.

Indeed, one of the enticing aspects of this book is that Professors Dimitriadis and McCarthy do not merely deconstruct or define the concept of postcolonialism. It might be said that they "*do*" postcolonialism, whether in tracing themes of suffering, migration, and slavery in Toni Morrison's work, or referring repeatedly to rap music, jazz, television, film, and newer technologies. They speak of Hindu drama being rediscovered in Trinidad, of the polyglot influences in the conversations between James Baldwin and the brilliant Third World scholar, C.L.R. James. They point to *Carnival*, a novel by Wilson Harris from Guyana, attacking the 19th century models of how novels should be written, presenting identities doubling on themselves as colonized and colonizer. The image of masks is introduced so that comfortable certainties such as "English teacher" or "history teacher" are made to drop away, only to be replaced by what seems strange at first but are actually richer more exciting realities which lure us to go further into our changing, kaleidoscopic world.

They include music and performance, too, in the revisions they propose to us, performances evocative of the youth culture, with all its blends and surprises and mysteries. The purely academic, the purely canonical, like the blandly termed "multicultural," are rejected, but this is not a bad-tempered, self-righteous affirmation of the modern or postcolonial in the face of professions bound to be reactionary. Things are left contingent, partial, wonderfully open and incomplete for the reader to develop and to realize, to be compelled to read what they have never done so, to look at pictures they have never seen, to attend to music they have heard only in the distance if at all. Indeed, this is how new worlds open, as they may well manifest themselves for teachers willing to take the risk suggested here and discover what postcolonialism in all its startling multiplicity signifies for a pedagogy still bound by what William Blake might have called the "man-made manacles" binding education to an outworn past.

Maxine Greene

Acknowledgments

This book is the result of a dialogue—a collaboration in the broadest sense of the term—begun over five years ago at the University of Illinois at Urbana-Champaign. Cameron, then an associate professor of curriculum and instruction, and Greg, then a new graduate student in speech communication, took part in a cultural studies and education reading and discussion group held every other Sunday afternoon at 4:00. The group, organized by Cameron, was modeled after one that his mentor, Michael Apple, conducted at the University of Wisconsin–Madison. Participants, graduate students and professors alike, came largely from various educational disciplines, though the Institute of Communications Research, speech communication, English, linguistics, political science, and anthropology, among other disciplinary sites, were represented as well. Doing work that placed them at the margins of their respective fields, all were drawn together by the notion that this group was important for the dissemination of cultural studies on campus. We thank past members of this group, including Ed Buendia, Stephen David, Nadine Dolby, Grace Giorgio, Abebe Fisseha, Heriberto Godina, Rochelle Gutierrez, Maureen Hogan, Lenora de la Luna, Shuaib Meecham, Carol Mills, Susan Noffke, Swarna Rajagopalan, Alicia Rodriguez, John St. Julian, Maia Seferian, Teresa Souchet, K. E. Supryia, and Carrie Wilson-Brown.

This group has come to reflect the changing interests of its members as well as new developments in the field. In particular, a focus on media studies and on poststructural theory, especially that of Michel Foucault and Giles Deleuze, has come to occupy the space once held by education and multicultural theory. This reflects, we believe, how the concerns that first drew us together in this group—the complexities of young people's lives, the ways pedagogy exceeds the interpretive frames offered in school—always keep us in search of new ideas, theories, and academic homes. Cultural studies has served, yet again, as a useful forum for addressing these concerns. We thank our new members, including Steve Bailey, Ted Bailey, Jack Bratich, Heidi Brush, Mary Coffey, Michael

Elavsky, Kelly Gates, James Hay, Lisa King, Samantha King, Marie Leger, Timothy McDonough, Shawn Miklaucic, Jeremy Packer, Carrie Rentchler, Craig Robertson, Rob Sloan, and Jonathan Sterne. In our attempt to understand and to act on our moment, we owe profound debts to these collaborators and interlocutors, as well as to others, including Warren Crichlow and Dennis Carlson.

We also have benefited enormously from the institutions we have been lucky enough to call home and the colleagues and teachers we are so fortunate to call friends. Greg just finished his second year at the University at Buffalo, in the department of Educational Leadership and Policy, in what could scarcely be a more supportive or enriching environment. He thanks all his students and colleagues, especially Lois Weis and Hank Bromley. He also extends his gratitude to those who have supported his work and his ideas along the way, among them William Youngren, William Fischer, Charles Keil, George Kamberelis, Norman Denzin, and Peggy Miller, as well as the late Lawrence Chisolm. This book documents the fruition of a long-standing collaboration between Greg and Cameron—a collaboration that has been a high point of both our academic careers. Cameron has enjoyed what his colleague (and wife) Angharad Valdivia calls "academic nirvana" at the Institute of Communications Research at the University of Illinois at Urbana-Champaign. He would like to thank his colleagues there, including Mark Alleyne, John Nerone (his newborn daughter Ailin's godfather), Cliff Christians, Norman Denzin, Andrea Press, Paula Treichler, and Bruce Williams. As always, he would like to thank Michael Apple.

This book could not have been completed without the support of four remarkable fellow "travelers." Carole Saltz and Catherine Bernard of Teachers College Press and philosopher Maxine Greene helped us to tease out the kernel of this book after a talk one of us gave to teachers and art educators at a salon held at Professor Greene's flat in Manhattan. In addition, we express our profoundest thanks to Laura Marks, curator/critic/author/editor extraordinaire, who provided us with a graceful critique of an early draft of this book that affected both its stylistic and conceptual form.

Introduction

Recent large-scale developments are wholly transforming social and cultural life outside and inside schools around the globe. These developments have enormous implications for pedagogical practice and the educational preparation of school youth—yet curriculum thinkers and practitioners have tended to dismiss or ignore them. These developments might be grouped under the term *multiplicity*, brought about by globalization and new electronic media, changing conceptions of self and other, and new explanatory discourses. These developments can be summarized as follows.

First, there is the broad set of processes that has come to be known as "globalization," or the intensified and accelerated movement of people, images, ideas, technologies, and economic and cultural capital across national boundaries. Driven forward by the engines of modern capital reorganization and the resulting changed interests, needs, and desires of ordinary people everywhere, globalization is sweeping all corners of the contemporary world. These processes are rapidly shrinking the distance between hitherto far-flung parts of the world, deepening the implication of the local in the global and the global in the local. While in the last century popular media such as television, film, newspapers, radio, and popular music had already expanded the range of information, images, and identities available to people, the power of globalization, fueled by migration and the new technologies of electronic mediation associated with computerization, has exploded the pace of this process in the new millennium.

Second, these developments have the potential to stimulate the imaginative work of the broad masses of the people. The expansion of representational technologies means that people now express their senses of past, present, and the future, their very destinies and their senses of self, in terms of the new mediascapes. These new mentalities and self-imagings are driven forward by an ever-expanding sense of possibility—as well as terror and constraint—as modern humanity cultivates new

1

interests, needs, desires, and fears in the landscape of the new media. These are the "dangerous crossroads" of media culture writ large, replete with profound possibilities as well as dangers (Lipsitz, 1994).

Third, and finally, new critical discourses have been generated, largely outside the field of education, to address the challenges of the new age. New interpretive frameworks abound. In the academic realm, these discourses include cultural studies, postmodernism, multiculturalism, and postcolonialism—the latter being the framework that integrates the various disparate elements and threads of our book. But in the realm of the popular, these interpretive frameworks are often formulated in the language of moral panic and its obverse, the language of panaceas and quick fixes. We are talking here about the panic/panaceas offered by psychic networks, extreme sports, stock options, e-trading, and the like that now dominate commercial advertising and the calculations of private citizenry as well as business. All of these developments, both critical and panicked, represent the triumph of multiplicity and the lack of clear answers now overtaking our daily lives. And they incite new challenges for the reproduction of increasingly unstable social orders generally and the practices of classroom pedagogy more specifically. Indeed, we are being compelled at every point to reconsider what pedagogy means in these circumstances.

Against the tide of these currents of change, however, mainstream educational thinkers, particularly in the United States, have tended to draw a bright line of distinction between the established school curriculum and the teeming world of multiplicity that flourishes in the everyday lives of youth beyond the school. These educators still insist on a project of homogeneity, normalization, and the production of the socially functional citizen. This is true even of contemporary, progressive approaches to curriculum reform, such as multiculturalism, that have sought to bring the problems of multiplicity and difference into a framework of institutional intelligibility and manageability. Thus proponents of the modern curriculum tend to speak a "technicist discourse"—a discourse of experts, professional competence, and boundary maintenance. As a result, while an unthreatening form of multiculturalism has been integrated into the curriculum, more critical discourses, such as Marxism, pragmatism, Frankfurt school critical theory, cultural studies, poststructuralism, and postcolonialism, have been left aside.

In *Reading and Teaching the Postcolonial*, we move in a different direction. We seek to bring into the field of education the critical mo-

mentum of interdisciplinary theories and postcolonial art and aesthetics. By *postcolonial art*, we mean artistic work engaged in the radical reassessment of center–periphery relations, produced in the crucible of colonization and its aftermath of independence and postindependence movements and struggles. We mean art engaged in rethinking the sharp, binary distinction between "colonizer" and "colonized" called forever into question by the worldwide independence movements that gained momentum in the latter part of the 20th century. This, of course, indexes a wide range of work developed in Africa, Asia, Latin America, and the Caribbean, as well as the peripheries of Western societies in Europe and North America. We have, however, avoided confining this work to geographical boundaries, recognizing that the "postcolonial" speaks to the complicated interrelations between the first world and the Third World. In this sense, for instance, the peripheries of the first world and even some of the latter's central institutions, as in the academy, have provided the profoundest type of nurturance for postcolonial aesthetics.

In using the term *postcolonial* we also seek to affirm the poignant sense of ambiguity, porosity, and translation that is expressed in the cultural forms of modern societies. Instead of breadth of coverage of these aesthetic and critical forms, however, we have sought to focus attention on a number of exemplars: the critical work of C. L. R. James and James Baldwin; the paintings of Arnaldo Roche-Rabell of Puerto Rico; Gordon Bennett, an Australian artist; the Haitian-American artist Jean-Michel Basquiat; and Wilson Harris of Guyana; and African American novelist and Nobel laureate Toni Morrison. We look, as well, at the circulation of popular "world musics" around the globe, focusing especially on DJ-driven dance musics like hip hop and techno. These exemplars from the margins, so to speak, offer striking transdisciplinary interpretations of the human condition. Postcolonial aesthetic formulations, we argue, have powerful implications for curriculum and educational practices in contemporary schools, challenged as they are by the rising tide of diversity and cultural change.

In the ensuing chapters, we will explore these postcolonial arts in order to problematize current pedagogical practices and the very organization of knowledge in schooling. We particularly focus on the way in which the mainstream educational field has addressed the topics of cultural identity, cultural difference, and cultural community. For instance, we argue in part that the contemporary hierarchical arrangement of schooling through its insistent processes of differentiation works both to

undermine and fragment student identity, producing a powerful ground of culturally significant distinctions between student and student, student and teacher, and so forth. We will read such approaches to education and culture against the open possibilities of knowledge production and ethical affiliation that are foregrounded in postcolonial art, literature, and popular music. We believe that it is pivotal to address these critical issues of cultural identity and the organization of knowledge at a time in which there are deepening patterns of cultural balkanization and disciplinary insulation in educational institutions.

THE PEDAGOGY OF RESSENTIMENT IN THE AGE OF DIFFERENCE

Friedrich Nietzsche's diagnosis of the modern condition speaks adroitly to our contemporary educational and social dilemmas and to center–periphery relations more generally. In his *On the Genealogy of Morals* (1967), Nietzsche insisted that a new ethical framework had come into being in the industrial age in which all patterns of human exchange were informed by the bureaucratic arrangements of social institutions. He called this moral framework "ressentiment" (resentment), or the practice by which one defines one's identity through the negation of the other. Forms of knowledge building; genres of representation; and moral, emotional, and affective evaluation and investments are all governed by ressentiment. We see this strategic alienation of the other at work in educational institutions' contemporary stance toward the topics of difference, multiplicity, and heterogeneity. We especially see ressentiment operating now in the fratricidal wars being waged on campuses across the country over the question of the canon versus multiculturalism and traditional disciplines versus alternative forms of knowledge, such as cultural studies and postcolonial theory.

More broadly, ressentiment is at work in popular culture and public policy in the United States—a country in which the professional middle-class dwellers of the suburbs have appropriated the radical space of difference to themselves, claiming the identity of social victim and social plaintiff. In so doing, the suburban professional class denies avenues of social complaint to its other, the inner-city poor. It projects its suburban worldview as the barometer of public policy, displacing issues of inequality and poverty with demands for balanced budgets, tax cuts, and greater

surveillance and incarceration of minority youth. All of this is accompanied by a deep-bodied nostalgic investment in Anglo-American culture and its European connections.

Of course, this framework of oppositions—these myriad oppositions between self and other—can be mapped a thousandfold onto Third World/first world relations today. But, ironically, these developments are taking place at a time when all over the world, migration, electronic mediation, and the work of the imagination of the great masses of the people have detached culture from place, creating new, polyglot, and heterogeneous cultural landscapes (Appadurai, 1996). The movement of peoples from Latin America, the Caribbean, Asia, Africa, and the Middle East to the United States has had the effect of reworking American culture and its very demographic character from within. In schools in Los Angeles, Texas, and New York, it is now not unusual to encounter classrooms in which the minority child is Anglo-American and in which English is effectively supplanted by Spanish, Armenian, Chinese, Korean, or Ebonics.

These transformations resulting from the worldwide movement and collision of people impose new imperatives on curriculum and pedagogy in schooling. However, we seem evermore in our era to lack empathy, the desire for collaboration and cooperation and negotiation, or the magnanimity of spirit to engage with the other as a member of our community—or even our species. In *Reading and Teaching the Postcolonial*, we therefore look to the world of postcolonial aesthetics for a language of critique and a language of possibility (Freire, 1970). We find these abandoned ethical values and strategies of knowing to deeply inhabit the postcolonial aesthetic works that we wish to foreground and analyze in this volume. By systematically transgressing genre confinement, by contesting social and epistemological hierarchies, and by operating in a plurality of registers, postcolonial art provides a paradigm of heterogeneous knowledge building, border crossing, and thoughtful dispassion toward cultural origins that best models a pragmatics of pedagogy for our times.

Postcolonial artists have reflexively apprehended and reformulated the processes of ressentiment into a new language of hybridity and critical humanism that foregrounds both the contradictions and the unsuspected trestles of association that cross the divide of center/periphery in the modern world. As critical scholars and educators, we are entirely compelled by the possibilities for educational rethinking that we see in this remarkable emergent tradition of aesthetic exploration.

POSTCOLONIAL THEORY

In highlighting the postcolonial, we thus look beyond the increasingly staid ways in which "multiculturalism" has come to mark contemporary debates in education. As we will argue throughout, these debates have been propelled by questions of "inclusion," often over the literary canon or the historical record, typically assuming stable ideas about culture, tradition, and identity (an idea we will develop more fully later) (McCarthy & Crichlow, 1993). The postcolonial, however, offers no such easy referents. It is a highly contested terrain. Indeed, as Stuart Hall (1996) provocatively asked in a recent essay, "When was 'the post-colonial'? What should be included and excluded from its frame? Where is the invisible line between it and its 'others' (colonialism, neo-colonialism, third world, imperialism), in relation to whose termination it ceaselessly, but without final supercession, marks itself?" (p. 242). Unpacking the "postcolonial," as Hall makes clear, is no easy task. For many, the term has a kind of elasticity that makes it all but meaningless, indexing, as it so easily can, *all* kinds of struggles for *all* kinds of independence against *all* kinds of domination in and around *all* parts of the globe. Hall asks:

> Is Britain "post-colonial" in the same sense as the US? Indeed, is the US usefully thought of as "postcolonial" at all? Should the term be commonly applied to Australia, which is a white settler colony, and to India? ... Can Algerians living at home and in France, the French and the Pied Noir settlers, *all* be "post-colonial"? Is Latin America "post-colonial", even though its independence struggles were fought early in the nineteenth century, long before the recent stage of "decolonisation" to which the term more evidently refers, and were led by descendants of Spanish settlers who had colonized their own "native people"? (p. 245)

This ambivalence can be disconcerting for some scholars, like Ella Shohat (1992), who fear that the proliferation of discourses about postcolonialism can be profoundly depoliticizing. Its plurality, its multiplicity, and its lack of political specificity are at the heart of these concerns.

Yet, for Hall—and for us—it would be a grave mistake to foreclose *a priori* the kinds of questions we can ask through the postcolonial by too prematurely and rigidly delineating its periods, time frames, figures, and the like. As Hall (1996) makes clear, postcolonialism "is obliging us to re-read the very binary form in which the colonial encounter has for so long been represented. It obliges us to re-read the binaries as forms

of transculturation, of cultural translation, destined to trouble the here/
there cultural binaries for ever" (p. 247). This conception of postcolo-
nialism evidences a kind of useful relationality through which to interro-
gate the postcolonial as a site of encounter between the "here" and
"there." Taken as such, the "postcolonial" can be thought of as a site of
dialogic encounter that pushes us to examine center/periphery relations
and conditions with specificity, wherever we can find them (p. 255). One
can no longer assume that "first" world agendas are simply reproduced
in the "third," but must pay special attention to the changeability of
material and discursive oppression in and across multiple, specific con-
texts (Quayson, 2000).

As used here, the "post" in the postcolonial is not to be understood
as a temporal register as in "hereafter," but as a marker of a spatial chal-
lenge of the occupying powers of the West by the ethical, political, and
aesthetic forms of the marginalized. Postcolonial art forms by novelists,
playwrights, painters, and musicians are products of colonial histories of
disruption, forced migration, false imprisonment, and pacification. The
violence of these colonial practices is so great that European aesthetics'
old claim on ethical and epistemological authority over knowledge and
of narrative fullness can only be treated as a hoax. Uneven development
between the metropole and the periphery plays itself out in aesthetic
form, in ways that problematize colonial/postcolonial power relations as
well as the Cartesian proposition of a self-sufficient, freestanding subject,
which, ironically, relies on colonial power relations for its existence. The
term "post" is meant to indicate the inseparability of center and pe-
riphery.

We maintain that educators today would do well to focus on the
complex analyses of center–periphery relations, the "here" versus the
"there," as they are produced and reproduced, theorized and critiqued,
in postcolonial music, art, and literature. Postcolonial art, we maintain, is
a site of the production of knowledge, one that has a critical pedagogical
dimension. In what follows, we take these reflections on center–periph-
ery relations to the terrain of the organization of knowledge in schooling
itself, particularly the difficult and highly contested issue of the reform
of the school curriculum and associated knowledge practices such as
classroom teaching. In turn, we take seriously a more socially extended
role for educational practices and a broader cultural location of contem-
porary educational and pedagogical tasks.

We thus point to the rich and complex set of questions raised by

postcolonial art, questions that have been largely contained and circum-scribed within the field of "postcolonial studies" itself (Afzal-Khan & Seshadri-Crooks, 2000). Indeed, the field of postcolonial studies has come to imply a certain circumscribed way of thinking—a certain set of theorists informing a certain set of issues and drawing on a specific set of texts. While it is in no sense a coherent field, it is, nonetheless, a field or "discourse." The names here are familiar—they include Hall himself as well as Gayatri Spivak (e.g., "Can the Subaltern Speak?," 1988), Homi Bhabha (e.g., *The Location of Culture*, 1994), and Paul Gilroy (e.g., *The Black Atlantic*, 1993), among others. As such, certain roads have been taken again and again while others have not been followed at all—for example, as Hall notes, there is a proliferation of work on literature but little work on the effects of global capitalism. We are encouraged to ask certain kinds of questions in and through the discourse of postcolonial-ism, but we are simultaneously encouraged to ignore others.

In this book, we attempt to look beyond the now ready-made ways of thinking about the postcolonial. In extending the discussion of the postcolonial to the field of pedagogy and education in general, we begin with a basic proposition—that there have been whole histories of critical work on the "postcolonial" condition that fall outside the ways of theo-rizing that have come to mark the field, and that these sober reflections on center–periphery relations in the area of culture have fundamental implications for education. We take our cue here from David Roediger, whose edited collection *Black on White* (1999) is a stunning intervention in the growing field of "whiteness studies"—one of the new, and highly contested, sites of the production of knowledge within the university curriculum that has ramifications at all levels of the educational enterprise (including teacher education). In this text, Roediger argues that turning a critical gaze on "whiteness" is not a new phenomenon, but is histori-cally embedded in generations of African American writing and folklore. He collects in this text examples of black people writing about white people, arguing that such discourse preexisted its slow incorporation into academic—albeit critical—circles.

Our work is in a similar spirit. We argue here that postcolonial artists themselves have theorized—and have been theorizing for many years—the tensions in and contradictions of the colonial encounter that have come to preoccupy scholars so recently. Artists have also opened up the spatial referent of the postcolonial landscape, suggesting that there is no necessary or fixed geography to center–periphery relations (Shange,

1983, p. 2)—that first world/Third World political and cultural bound-aries are highly permeable and diffuse—and that there are peripheries of the center as well as centers of the periphery. The work of these artists reveals the complexity of power relations in the postcolonial world, call-ing attention, for example, to the way in which Third World elites them-selves produce and reproduce colonizing perspectives along the entire divide of center–periphery relations (Edward Said provides an extraordi-narily moving personal account of these predicaments of postcoloniality in his *Out of Place* [1999]). The work of postcolonial artists calls central attention to the production of values, dispositions, and commitments; the terrain of knowledge production itself; and the ground of educa-tional reproduction.

Postcolonial artists are exemplars of new models of thoughtfulness and herald a new way to organize knowledge relating to both minority and majority actors in education life. Blurring the line between peda-gogy, activism, and art, these novelists, painters, critics, and musicians offer compelling resources for educators attempting to understand an increasingly complex set of global forces and trajectories and the impact of these dynamics on their immediate environments—the classroom and the school context. These artists are both theorists and pedagogues in their own right, exceeding easy categorization.

Indeed, we take pains not to elide the enormous critical energies that circulate between and across these art forms, but rather to look at them as sites of critical reflection in dialogue. They offer strategies of contradiction, ambivalence, irony, and satire in order to disrupt any sim-plistic reproduction of first world cultural agendas in the third. The com-mon separation between artists, art forms, and practices into neatly delin-eated genres and disciplines is an illusion that belies the dynamic history of dialogue between postcolonial artists and intellectuals around the globe. This model of conversation and dialogue between artists/intellec-tuals across the boundaries of nation, location, and culture is a particu-larly exemplary practice for educators, in the classroom and elsewhere, to emulate.

Following Paulo Freire (1970), we believe that "dialogue . . . re-quires an intense faith in humankind, faith in their power to make and remake, to create and re-create. . . . Faith in people is an *a priori* require-ment for dialogue" (p. 71). Dialogue, in this sense, challenges us to make and remake our own emancipatory educational practice. It chal-lenges us to rethink the discourses in which we operate and the lan-

guages we use to fashion the ethics of our professional lives. It asks us to look beyond our inherited way of thinking and acting, to new, unexplored, and perhaps even dangerous pedagogical practices. The role of the educator cannot be easily contained today.

AN OVERVIEW

The rest of the book will unfold as follows: In Chapter 1, we will begin to explore the book's key arguments about art, aesthetics, and education. Contemporary critical thinking on the status of art, we argue, tends to favor one of three approaches: antipopulism, populism, and finally postmodernism. These approaches, however, have tended to ignore the imaginative, creative, and historically specific work of colonized people in the Third World and on the periphery of the first. The work of the postcolonial imagination subverts extant power relations, questions authority, and destabilizes received traditions of identity. It offers, in turn, new starting points for affiliation and community that draw on the wellspring of humanity. In an attempt to give some shape to the "postcolonial imagination," we introduce the key motifs of postcolonial art here—counter-hegemonic representation; double or triple coding; and utopic and emancipatory visions—and show their particular resonance for education.

In Chapter 2, we look at the critical work of C. L. R. James and James Baldwin. In particular, we foreground the extended conversations of C. L. R. James and James Baldwin—exchanges on the part of two postcolonial actors whose early intellectual and aesthetic orientations were fashioned in two very different political cultures; for James, in the Third World, and for the American Baldwin, on the periphery of the first. We consider these artists/intellectuals to be public intellectuals. Following Henry Giroux (1996), "the public intellectual travels within and across communities of difference, working in collaboration with diverse groups and occupying many locales of resistance while simultaneously defying the specialized, parochial knowledge of the individual specialist, sage, or master ideologue" (p. 137). James and Baldwin would wander around the globe in the effort to break down the constraints of racial origins, geographical locations, and disciplinary boundaries and vocabularies. We see a certain disposition toward critical work here—a blurring of distinctions between the high and the low, an investment in

public culture and political activism, a sincere vocation to be more fully human. Such a disposition—intellectually engaged, politically committed, and humble in the extreme—marks the spirit of the dialogue we want to encourage.

In Chapter 3, we explore the postcolonial condition of multiple heritages that the Guyanese novelist Wilson Harris mines in novels such as *The Palace of the Peacock* (1960), *Companions of the Day and Night* (1975), and most especially *Carnival* (1985a). Drawing on Mikhail Bakhtin's notion of the carnival, we argue that Harris works from medium to medium to tell a story that attacks the authentic subjectivity and the hierarchy of discourses associated with the 19th-century novel. We focus, in this chapter, on a new subject identity at the epicenter of Harris's novels: a twin or double figure of reversible sensibility and feeling, neither colonizer nor colonized but both; a shadow and a mask rising from the ruins of colonial historical realities; an allegorical trope of the new society. Ultimately, we explore the implications of Harris's writings and the "carnival" for curriculum construction.

In Chapter 4, we examine the open-endedness of history in the novels of Toni Morrison. Looking back to an infinite past, in novels such as *Beloved* (1987), *Jazz* (1992), and *Paradise* (1998), Morrison generates mythologies rooted in countermemory about blackness that allow for infinite kinds of futures, futures imbricated in hybrid understandings of identity. What we see in Morrison is a complex process of forgetting and remembering, one that places tremendous responsibility in the hands of the author or the storyteller. In this trilogy, Morrison opens up key moments in American history for more intensive exploration and problematization: slavery (in *Beloved*), the black migration from the South to the North (in *Jazz*), and the search for black autonomy and community throughout the 20th century (in *Paradise*). In so doing, Morrison encourages teachers to present historical knowledge as incomplete, to endow students with responsibility in its construction.

In Chapter 5, we look at the painters Gordon Bennett, Arnaldo Roche-Rabell, and Jean-Michel Basquiat. All three, in our view, have wrestled with the available tools of the colonial imagination in pursuing new and complex identities as well as broad political visions. Their contradictory, hybrid, and utopian texts agonize about identity and present the future as an open ground of possibility and negotiation, resounding with the polyglot voices of the marginalized and oppressed. For each of these artists, social, political, and economic transformation cannot be

dictated: It is a process without the false security of stable identities and origins. We submit that these artists have theorized about "tradition" in more complex and interesting ways than much work in multiculturalism today, offering up a reinvigorated terrain for educators.

In Chapter 6, we extend our discussion of literature and visual art to include music and performance. We argue that contemporary popular music and performance practices are the product of multiple, overlapping, and complex cultural trajectories—the "dangerous crossroads" of aesthetics and politics (Lipsitz, 1994). Artists today have at their disposal a rich and varied archive of recorded material for creative appropriation. From rap music sampling to the new links between world music and dance culture, musicians are conjuring up new kinds of social affiliations, affiliations that challenge the ready-made theoretical constructs of academics and pedagogues alike. Contemporary youth music is very complex, a dizzying blend of genres and styles that belies the ability of record companies to easily target and commodify them. We see a highly complex intersection here between performance, identity, and community, enacted in practice among young people today. Educators can learn from music's ability to draw from worldwide sources in building these new kinds of communities.

In the concluding chapter, we explore the ways in which a rich and complex understanding of postcolonial art can help us contest discourses of ressentiment at work in popular and academic culture today. Postcolonial artists and theorists, we conclude, challenge us to rethink the ways in which knowledge is stratified and the constitutive relationship of pedagogy to critical, politically applied work.

Throughout this book, we attempt to take the evaluation of postcolonial art and these artistic practices beyond tendencies to valorize them as individual icons and to treat them as reified or atomized works. It is these educational practices of intellectual isolationism and positivism that have too often come to define contemporary approaches to existing curriculum arrangements and reforms. The histories of dialogue and struggle that have marked the work of art in the postcolonial imagination can be linked to broader struggles for freedom, struggles that cannot be understood from within simple disciplinary confines, but must speak between and beyond them. These artistic practices are, inexorably, political projects that, to echo Hall, do not fit neatly into disciplinary or even postdisciplinary structures. They are not "disciplined pedagogies." They

are part of a broader human struggle, taking place across multiple sites of encounter. They prefigure an expanded and contrapuntal pedagogical project (Said, 1993) that seeks to link the task of educating to the transformation of center–periphery relations wherever we encounter them in our social world.

Art as Theory, Practice, and Reflection

*The Radical Dimensions of the
Postcolonial Imagination*

We find ourselves today facing heretofore unimagined social, economic, and cultural dislocations—dislocations that have clearly overwhelmed educators, outstripping the models of learning and pedagogy privileged in the academy (generally) and schools of education (specifically) today. Over the past several years, we have struggled as educators in pursuit of change—in search of new models; new theories; new intellectual ancestors; and new ways of thinking, acting, and being as transformative intellectuals. Though clearly not exhaustive, our search has taken us beyond educational theory and research to the overlapping spaces of criticism, literature, visual art, and music. Our search has taken us to "the postcolonial imagination" writ large—to critics, visual artists, novelists, and musicians. As we argue throughout this book, the complex modern challenges now confronting educators are better anticipated and foregrounded in the arts—both dynamic new postcolonial art forms and popular culture—than in the mainstream classroom.

The critical and emancipatory goals of postcolonial art, we suggest, can and should inform the necessarily complex deliberations on the current state of the educational enterprise. We believe that postcolonial art's proliferation of representations offers new ground for educational and pedagogical tasks and imperatives. For, as critical cultural observers such as Len Masterman (1990) and Henry Giroux (1996) have demonstrated, the terrain of education has been overtaken by unruly and multiple signs, symbols, and representations. Pedagogical tasks are ever more insistently being taken up in the sphere of culture (film, television, the Internet, computer games, music, art, and fiction) outside of the classroom proper. Educators need to rearticulate a dialogue between the educational enterprise and the world of unequal center–periphery relations in which we live. This is the direction that postcolonial art has been point-

ing us in all along—toward a foundational dialogue that challenges us to remake the terms of the educative enterprise itself.

IMAGINATION, EDUCATION, AND THE
SEARCH FOR POSSIBLE FUTURES

Postcolonial arts, we will show, offer educators a rich new set of resources for thinking about issues and concerns that seem ever more beyond our grasp and control (as outlined in the Introduction). These arts help us resist the ressentiment logics that seek to bring premature closure to these now inextricably global social, economic, and cultural concerns. In this regard, we find common cause with Maxine Greene's (1995) extraordinary efforts to challenge the banality, the thoughtlessness, and the efforts at technical rationality that so mark the field of education today. For Greene, the work of the imagination "allows us to break with the taken for granted, to set aside familiar distinctions and definitions" (p. 3), and look toward different kinds of social affinities. She writes,

> Now, with so many traditional narratives being rejected or disrupted, with so many new and contesting versions of what our common world should be, we cannot assume that there is any longer a consensus about what is valuable and useful and what ought to be taught, despite all the official definitions of necessary outcomes and desired goals. (p. 3)

For Greene and for us, the work of imagination opens up a profoundly deliberative space, one that allows us to re-vision contemporary "common sense" about education in compelling and creative ways. The imagination takes us at least one or two steps back from the *a priori* declarations of "consensus," "necessary outcomes," and "desired goals" that seem to propel the mainstream field of education today.

Greene's work seems particularly fruitful for thinking through the full ramifications of our contemporary postcolonial moment. As indicated earlier, imaginative work today is no longer the sole providence of "specially endowed (charismatic) individuals." Rather, "the imagination has broken out of the special expressive space of art, myth, and ritual and has now become part of the quotidian mental work of ordinary people in many societies" (Appadurai, 1996, p. 5). New uses of the imagination

have enabled new ways of envisioning self, other, and community that exceed modernist narratives of nationalist educational imperatives.

In taking seriously the contemporary imagination, we underscore our own evolved inability to deal with the contemporary field of education in any sort of complete way. We, as educators and critics, no longer have the kind of control over our subject matter that would allow us to grasp our moment with any sort of fullness or completeness of vision. Education today is an emergent and unfinished idea. In fact, the very idea of research as a privileged space of expert knowledge has been called into question, as the "symbolic analysis" of "artists, journalists, diplomats, businessmen, and others" now sits side by side with the efforts of academics as attempts to understand the complexities of this moment (Appadurai, 2000, p. 8). Following Yvonna Lincoln and Norman Denzin (2000), our moment necessitates new and overlapping roles for ethics, aesthetics, and the civic—and it is replete with possibilities and potential dangers. While we can no longer rely on the models and the constructed certainties of the past, they stress, "we also have enormous opportunities to make of the future what we wish it to be" (p. 1061). We are reminded here of Lois Weis and Michelle Fine's (2000) recent work on "free spaces," or the ways in which young people themselves are imagining and enacting different kinds of education, both within and outside traditional school settings, often through the arts.

Above all, we are reminded of the extraordinary commitment to an open-minded popular education and cultural awareness that one finds in the aesthetic thought and in the work of postcolonial artists such as Mona Hatoum, George Lamming, Gordon Bennett, Toni Morrison, Wole Soyinka, Chinua Achebe, or Ngũgĩ wa Thiang'o. This commitment to a popular pedagogical aesthetics helps to distinguish the work of the imagination in the postcolonial arts from that of more mainstream Western artists (see, for example, Patrick McGee's discussion [1993] of Kenyan writer Ngũgĩ wa Thiang'o's [1982] pedagogical use of his novels).

In this chapter, we look toward a richer understanding of the postcolonial imagination. In doing so, we wrestle with how to define our object of study, how to bring some specificity to this work without pasting over complexities and contradictions. This struggle is an acute one, as the field of critical work is fairly delimited and invites early disciplinary closure.

CONTEMPORARY APPROACHES TO THE ARTS

Contemporary critical thinking on art and aesthetics, we argue, tends to take one of three approaches. Each of these approaches has contributed enormously to our understanding of the role of art in contemporary life, influencing a generation of first world critics in profound ways. Yet a major—indeed debilitating—constraint common to all three is that they cannot account for the specific circumstances of colonized people in the Third World and on the periphery of the first. Contemporary critical theories of art tend to disavow or silence the historical specificity and productivity of postcolonial artistic and cultural practices, a crucial and paralyzing elision.

The first approach has its roots in the work of Frankfurt School theorists such as Theodor Adorno, Max Horkheimer, and more recently Jurgen Habermas. This approach can be described as *anti-populist*. Proponents of anti-populism argue that the modern aesthetic object is little more than a work of capitalist wish fulfillment. The modern art object is located squarely in the metropolitan center, its elaboration of capitalism and its sinuous culture industry. Modern art, in the anti-populist view, is so compromised by the routinization and mass mediation of the culture industry that it has lost its unique capacity to critique or instruct (Adorno, 1980; Held, 1980).

The second approach in contemporary critical studies of art is linked to a more charitable view of art. This discursive move is *pro-populist* (McGuigan, 1992) and can be genealogically traced to the alternative wing of the Frankfurt School in treatises such as Walter Benjamin's "The Work of Art in the Age of Mechanical Reproduction" (1968) and more recently to Cultural Studies of the Birmingham School in England and its analogous traditions in Australia, Canada, the United States, and elsewhere. This approach sees contemporary art as participating in processes of political resistance, offering the masses a way out of the pitiless and inexorable logic of capitalism.

The third approach distinguishes itself from the previous two by suggesting a temporal shift in human sensibilities, the nature of capitalism, and alas, art itself, toward a contemporary condition in which the connection between art and society is severed, releasing new radical energies of multiplicity, irony, and destabilization. This approach to contemporary art goes under the banner of *postmodernism*. Postmodern cultural critics such as Charles Jencks argue that we have entered a new millen-

nium in which all hierarchies, from social organization to international relations to aesthetics, are being replaced by loose, non-hierarchical structures whose omnivorousness is aided by a computerization of all areas of life. In the postmodern world art does not imitate life; life is aestheticized, and art is the genetic code for the new forms of existence and the care of the self.

At best, anti-populist, pro-populist and postmodern criticism are capable of understanding aesthetic creations of the Third World only as some kind of Baudrillardian counterfeit, the (Third World) copy that desires the place of the (first world) original, but has no real aesthetic or intellectual home of its own. Postcolonial art is thought to arise, via what Homi Bhabha (1994) calls a "time lag," in the tracks of the more dominant art discourses of the West. It is considered a harlequin patched together from borrowed robes, a figure caught in the undertow of Western art and wrestling anxiously to the surface for air. By contrast, in this chapter we will offer some thoughts toward a new understanding of postcolonial art, attending to its historical specificity and productivity in careful and, we hope, richly suggestive ways.

In what follows in this chapter, we discuss some critical features of postcolonial art by analyzing the work of a number of artists from the Third World and from the periphery of the metropole. In so doing, we highlight the social and imaginative space these artists share, the themes and tropes that run across these art forms and mark them as historically and politically distinct. However, we offer no new theory here, nor do we wish to subsume the work of these artists within a new, overarching "meta-narrative." The work of these artists, we found, has consistently exceeded the explanatory frameworks we have brought to bear upon them. We thus look for specificity in this art as we are continually alerted to its variability—a tension that will propel us through ensuing chapters in which we explore in more detail what these artists have to offer the field of education today.

 We want to highlight, in particular, three important motifs and directions of the work of art in the postcolonial imagination and draw a few conclusions. These three motifs—*counterhegemonic representation, double or triple coding*, and *emancipatory or utopic visions*—help define an emergent postcolonial aesthetic.

First, we consider postcolonial art's vigorous challenge of Western models of classical realism and technologies of truth, which preserve the unity of the Western subject. Second, we suggest that the work of art

in the postcolonial imagination effectively rewrites the binary logic of modernity that privileges the place of the West and empire by creating oppositions of "center" and "periphery," "developed" and "underdeveloped," and "civilized" and "primitive." Third, we look at the way in which the work of postcolonial artists foregrounds an emancipatory critical reflexivity and thoughtfulness that allow the artist to look upon his or her own traditions with the dispassion of what Walter Benjamin calls "melancholy" (1977). By melancholy, we do not mean a state of self-absorbed sadness or depression, but the whole process of historical alienation from received tradition understood as eternal truth. The melancholic artist therefore questions and problematizes inherited cultures and tradition using this approach to explore the full complexity of the human condition as a whole. These practices of "melancholic" skepticism and self-vigilance serve as critical elements in the aesthetic attempts of postcolonial artists to visualize a utopian community in which criteria for membership are not given *a priori*, in an inherited set of characteristics or a political platform.

We will now discuss each motif, bringing in illustrative examples from the works of a representative number of artists. Not all these artists will be discussed beyond this chapter. But in later chapters we will revisit more carefully a small coterie of them (Wilson Harris, Toni Morrison, Gordon Bennett, Arnaldo Roche-Rabell, and Jean-Michel Basquiat) as we show how their work provides a depth of vision for aesthetic and pedagogical alternatives. We turn now to the postcolonial scrutiny of the theme of hegemonic representation.

THE CRITIQUE OF HEGEMONIC REPRESENTATION

Traditions of European aesthetics—for example, in the art of the novel or perspectival oil painting—construct a freestanding subject at the heart of aesthetic work and address an equally coherent and fully integrated subject in the implied reader or viewer (Belsey, 1980; Berger, 1972). Both colonialism and perspectival imaging trace the emergence of a unified subject in Europe and European colonies. As Gayatri Spivak (1988) argues, even when the work of antimodernist/postmodernist writers foregrounds narrative collapse, what collapses is still a singular overmastering voice (see, for example, François Lyotard's *The Postmodern Condition* [1984] or Michel Foucault's *The Care of the Self* [1988]). In con-

trast, what we find in the work of the postcolonial artist—in the installations of Mona Hatoum or Young Soon Min, in painters such as Gordon Bennett, the Guyanese Aubrey Williams, or Indrani Gaul from India, in writings such as Wilson Harris's *The Palace of the Peacock* (1960), Isabel Allende's *The House of the Spirits* (1985), Wole Soyinka's *The Interpreters* (1965), Ayi Armah's *The Beautyful Ones are not yet Born* (1968), or Toni Morrison's *Song of Solomon* (1977)—is the effort to visualize community, a new community of fragile and polyglot souls. In contrast to the postmodern position, in postcolonial art the self is embedded in communal—though hybrid and multiple—trajectories. There is always an effort to link individual will and fortune to collective possibility.

Thus, postcolonial African writers like the Nigerian Wole Soyinka directly challenge the 19th-century novel's hierarchical arrangement of character and its insistence on a rational interiority or persona and verisimilitude of context and situation. In novels such as *Season of Anomy* (1974) and *The Interpreters* (1965), Soyinka offers up a set of characters who exist as principles or forces. They are parabolic characters or types. Their sense of interiority is diminished as they function as the carriers or vehicles of a Yoruba tradition engaged in a struggle with Western hegemony. The urbanized Lagos of *The Interpreters* exists as a cultural melting pot for all types of people and situations—a polyglot world populated by characters that we can hardly separate from one another. Our moral guides are Egbo, a Foreign Office diplomatic clerk; Sagoe, a journalist; Sekoni, an engineer and sculptor; Kola, an artist and Bandele University lecturer; and Lasunwon, a lawyer. These are "the interpreters," idealistic but hopelessly incorporated, even as they struggle against the corruption of European values and cultural forms that dominate modern Nigerian life. These characters collectively form a center of resistance alienated from the teeming, pretentious, and crassly materialistic world of post-independence Lagos.

Soyinka weaves into this social cauldron the brooding presence of the gods of Yoruba mythology and ritual. Time and space are altered, and events proceed within an unfolding ledger of fantasy and the constant subversion of reality. To transcend the spiritual wasteland of the city of Lagos, the interpreters must experience symbolic or real deaths, epitomized by Sekoni's passing. Narrated as the fulfillment of a ritual sacrifice to the god Obtala, Sekoni's death is compared to that of the dying bull in a Spanish bullfight (even death does not escape the narrator's satire and deep suspicion of the technological gifts of Westernness):

> The rains of May become in July arteries of the sacrificial bull, a million
> bleeding punctures of the sky-bull hidden in convulsive cloud humps. . . .
> The blood of earth dwellers mingles with blanched streams of the mock-
> ing bull, and flows into currents eternally below the earth. The dome
> cracked above Sekoni's short sighted head one messy night. Too late
> the insanity of a lorry parked right in his path, a swerve turned into a
> skid and a cruel arabesque of tires. A futile heap of metal, and Sekoni's
> body lay surprised across the open door, showers of laminated glass
> around him, his beard one fastness of wet blood. (Soyinka, 1965, p. 155)

Soyinka's critique of imperialism is delivered in a novel in which men
double up as gods and struggle to reconcile the ridiculousness of their
world with fantasy, ritual, and tradition.

One is reminded here of the fiction of other African novelists such
as Ayi Armah (*The Beautyful Ones are not yet Born*), Bessie Head (*A
Question of Power* and *When Rain Clouds Gather*), and Ngũgĩ wa Thi-
ang'o (*Devil on the Cross*)—a fiction that offers, like Soyinka's, a wither-
ing critique of the excesses of Europeans in Africa while at the same time
exposing the ambivalence of cultural heritage that defines modern Afri-
can identity. Like their creators, characters in the African postcolonial
novel struggle with their colonial intimacy as illustrated by the protago-
nist of Ngũgĩ's *Devil on the Cross*, Wariinga, whose tormented dreams
are the revelation of a divided personality as well as the staging ground
for an ideological struggle over cultural imperialism:

> Instead of Jesus on the cross, she would see the devil, with skin as white
> as that of a very fat European she once saw near *The Rift Valley Sports
> Club*, being crucified by people in tattered clothes—like the ones she
> used to see in Bondeni—and after three days, when he was in the throes
> of death, he would be taken down from the cross by black suits and
> ties, and, thus restored to life, he would mock Wariinga. (Ngũgĩ, 1982,
> p. 139)

Like Soyinka and Ngũgĩ, the Puerto Rican painter Arnaldo Roche-
Rabell uses his work to problematize contemporary existence on his is-
land, dominated as it is by the impositions of the United States. Roche-
Rabell also challenges the hegemony of the Western aesthetic norms in
which he was schooled while showing their contradictory impact on the
modern Puerto Rican subject. His deliberately oversized oil paintings,
published in the catalogue *Arnaldo Roche-Rabell: The Uncommonwealth*

(Hobbs, 1996), are particularly illustrative of Puerto Rico's struggle to construct identity and subjectivity from the fragments of an agonizing and tragic history. Roche-Rabell prosecutes his concern with the politics of identity and anti-colonialism in the creation of larger-than-life figures that often seem buried or interred in some kind of deeper structure. These figures are denied corporeal completeness or unity. And like Soyinka's characters, Roche-Rabell's figures are principles or parabolic types—protean sources of ambiguity or hybridity. In the canvas mural *Poor Devil* (1988), to give one example, the face of the devil seems thickly and densely overlaid, applied with multiple levels of red paint, on the head of a blue-eyed man. Roche-Rabell gives form to the repressed demons and monsters produced in Puerto Rico's history of colonization. His concern with the twinness or doubleness of personality and flawed subjectivity connects the themes of anti-colonialism and the themes of refusal of coherent subjectivity.

The devil folk mythology of the French Caribbean humanizes the powers of extreme evil in Derek Walcott's (1970) plays *Ti Jean and His Brothers* and *Dream on Monkey Mountain*. The devil as a trope of folk rejection of capitalism is also present in the lore of many plantation cultures throughout the Caribbean and Latin America, as Michael Taussig (1980) tells us in *The Devil and Commodity Fetishism in South America*. But Roche-Rabell adds a twist to this set of observations: the devil is in all of us. The postcolonial soul is damaged, but in its double or multiple personality, a new community is waiting to be born.

The utopian construction of community recurs across a range of traditions and historical contexts, including in the work of postcolonial African American novelists such as Toni Morrison. Morrison's novels mine a broad range of literary and vernacular traditions—from the Judeo-Christian Bible to the work of Shakespeare to African American spirituals to African folklore to blues and jazz and beyond. In this polyglot, alchemical manner, Morrison forges a vision of black communities that are both fragile and highly resilient, communities girded by traditions that are always open and subject to multiple manifestations. Her characters enter the fictive world as partial, fragmented selves ceaselessly reconstructing the past in the present, always in an open-ended and protean fashion.

For example, the novel *Jazz* (Morrison, 1992) places us in the middle of a culturally brimming Harlem Renaissance following a murderous love triangle that plays itself out by way of the rhythms and tempos of

that most protean and improvisational of musical idioms, jazz. Indeed, *Jazz* does not unfold in traditional narrative form (however melodramatic the "plot" might seem). Like jazz itself, the text layers multiple voices on top of one another, blurring the line between what has been composed in the past and what is realized in the moment, making linear narrative progression seem entirely anomalous.

Jazz is an appropriate and telling metaphor for the processes of community construction at the heart of this novel. Displaced Southerners in black Harlem must forge selves—improvisatory voices, so to speak—by way of a contingent group identity. This is delicate business. Ralph Ellison explores this connection between jazz improvisation and the constructed nature of marginalized identities in his essay on jazz, "The Charlie Christian Story" (1972). In an often-quoted passage, he notes:

> There is a cruel contradiction implicit in the art form itself. For true jazz is an art of individual assertion within and against the group. Each true jazz moment . . . springs from a contest in which each artist challenges all the rest; each solo flight, or improvisation, represents (like the successive canvases of a painter) a definition of his identity: as individual, as member of the collectivity and as a link in the chain of tradition. Thus, because jazz finds its very life in an endless improvisation upon traditional materials, the jazzman must lose his identity even as he finds it. (p. 234)

This tension of finding, losing, and finding oneself in and through dynamic, traditional group processes is on every page of *Jazz* and the rhythms and cultural practices on which it draws.

The search for identity is thus a search for a collective self that connects the disenfranchised to multiple traditions, both global and local. This hybridity of culture, so evident in the work of such artists as Gordon Bennett, Toni Morrison, and Nicholas Guillen, transforms the binary oppositions privileged in the brutal colonial imagination: West versus East, North versus South, the high versus the low, the civilized versus the primitive. Transcending these binary oppositions allows these artists to rework the center-versus-periphery distinction that has so undergirded the iconography and social sciences of Western intellectuals, in order to look beyond its strictures to new histories, new discourses, new ways of being.

We offer one last example of the plurality and multiplicity that one finds in the work of Third World artists: the celebration of epic Indian

ritual in everyday life in a distant corner of the Caribbean, in the work of the St. Lucian Derek Walcott. In his 1993 Nobel lecture, "The Antilles: Fragments of Epic Memory," Walcott talks about taking some American friends to a peasant performance of the ancient Hindu epic of Ramayana in a forgotten corner of the Caroni Plain in Trinidad. The name of this tiny village is the happily agreeable—and English—"Felicity." The actors who spin this immortal web of memory, ancientness, and modernity are the plain-as-day East Indian villagers. Walcott is "surprised by sin" as the simple native world unfurls in its utter flamboyance:

> Felicity is a village in Trinidad on the edge of the Caroni Plain, the wide central plain that still grows sugar and to which indentured cane cutters were brought after emancipation, so the small population of Felicity is East Indian, and on the afternoon that I visited it with friends from America, all the faces along its road were Indian, which as I hope to show was a moving, beautiful thing, because this Saturday afternoon Ramleela, the epic dramatization of the Hindu epic of Ramayana, was going to be performed, and the costumed actors from the village were assembling on a field strung with different-colored flags, like a new gas station, and beautiful Indian Boys in red and black were aiming arrows haphazardly into the afternoon light. Low blue mountains on the horizon, bright grass, clouds that would gather colour before the light went. Felicity! What a gentle Anglo-Saxon name for an epical memory. (p. 1)

The world on the Caroni Plain integrates the ancient and modern, as Indian peasants historically displaced to the Caribbean create in their daily lives a re-memory of their past before modern colonialism. In so doing, they add an extraordinary ritual and threnodic nuance to the folk culture of the Caribbean as a whole. In the art of living, these East Indian peasants triumph over the imposed history of marginalization and the Middle Passage history of indentureship.

Ultimately, these artists all wrestle with the question of hegemonic representation, with how to look past ways of ordering the world that rely on the kinds of binaries discussed above. These artists encourage us to look toward new and less prefigured terms of identification and association. They offer unique resources for educators struggling to speak with young people who are negotiating identities that often exceed easy predictive categories.

THE STRATEGY OF DOUBLE CODING

A second mode of meaning construction in works of art in the postcolonial imagination is the strategy of double coding. By *double coding* we mean the tendency of the postcolonial artist to mobilize two or more fields of reference or idiom in any given work, or what Wilson Harris (1989) calls "the wedding of opposites." The postcolonial artist may therefore quote or combine the vernacular and the classical, the traditional and the modern, the cultural reservoir of images of the East and the West, the first world and the Third, the colonial master and the slave. Again, we want to distinguish this strategy from the type of double coding that postmodernist critics such as Charles Jencks (1996) talk about when defining postmodernism. Instead of foregrounding the collapse of master narratives through the individualistic deployment of competing codes, we are pointing to the use of double coding to serve the collective purposes, collective history, and visualization of community that constitute the central issues in the postcolonial artistic project.

The filiation of such strategies, as Paul Gilroy notes in *The Black Atlantic* (1993) and in his essay "Cruciality and the Frog's Perspective" (1988–89), can be traced to the historical practices of marginalized groups. For example, the code switching and multiple articulations or revisions of Christian hymns by African slaves allowed them to circulate meaning around and beyond the gaze of plantation owners. Similarly, the Africanesque revision of Catholicism in the Voudun Candomble religions of Haiti and Brazil, respectively, represents a popular expression of the subaltern subject's use of double and triple register.

The strategy of double coding is powerfully foregrounded in the work of the Aboriginal painter Gordon Bennett (McLean & Bennett, 1996). As we will discuss more fully in Chapter 5, one of his pivotal paintings, *The Outsider* (1988), combines the methods of Aboriginal pointillism and Western perspectival painting to stunning effect. This painting ironically quotes Vincent van Gogh's *Starry Night* (1888) and *Vincent's Bedroom in Arles* (1889), replacing their tense, disturbing calmness, perhaps expressions of van Gogh's imminent madness and suicide, with an atmosphere of brusque, startling anxiety. Bennett's double coding of European and native traditions exposes an unsettling environment of cultural hegemony, highlighting the incompleteness of the modern Aboriginal search for identity. To be homeless in one's home—to inherit

both the wealth and violence of the encounter between indigenous and European cultures—is the fundamental postcolonial condition.

One is reminded here of the video installation work of the London-based Lebanese Palestinian artist Mona Hatoum, recently on exhibit at the London Tate Modern Museum. In an intensely personal, multilayered, fifteen-minute video entitled *Measures of Distance* (2000), Hatoum explores the gendered dimensions of Palestinian life under Israeli occupation. This experimental video depicts Hatoum's mother taking a shower. The video has no "plot" as such, but it relays a series of letters that were exchanged between Hatoum and her mother during the 1982 Israeli military offensive in Lebanon. The letters, written in Arabic calligraphy, are superimposed on the image of Hatoum's middle-aged mother bathing—a matter of everyday life in the context of this incongruous, surreal war. The effect of the superimposition of Arabic calligraphy over the nude body of this middle-aged Palestinian woman is that of barbed wire. The nude figure is muted, and viewers are prevented from having clear access to her body by the Arabic text that is superimposed on her image.

These images are accompanied by a multilayered soundtrack that features Hatoum's melancholy and monotone reading of the letters as well as a recording of the animated conversation between Hatoum and her mother in Arabic. Fading in and out of this audio text is the voice-over of a narrator translating the Arabic conversation into English (Archer, Brett, & De Zegher, 1997; Ritsma, 2000). This multifaceted video installation works to distance us from any coherent sense of the subject and from prescriptive standards of beauty. The Western nude aesthetic is imbued with powerful ideological critique. And the installation activates multiple cultural registers and schemes of reference. Above all, we are reminded of the precariousness of modern Third World subjectivity and the multiple constraints imposed on the subjectivity of diasporic women in particular.

The deconstruction of the fantasy of authentic origins, the clear-cut hierarchy of "high" and "low," is realized most explicitly in the work of Jean-Michel Basquiat (Marshall, 1995). Basquiat's early career was as a graffiti artist in New York City, painting SAMO—"Same Old Shit"—on myriad public spots throughout Manhattan. (Interestingly, this early alter ego took shape in New York City's alternative City-as-School, where Basquiat attended high school and wrote for the school newspaper [Ho-

ban, 1998].) Basquiat was part of the burgeoning and (then) vibrantly multiethnic hip-hop cultural movement in New York City, a movement that integrated in equal measure rap music, break dancing, and graffiti writing (in fact, Basquiat produced a single featuring rapper Rammell-zee). While his work contains numerous references to these and other cultural signifiers, Basquiat's work draws, most interestingly and with great complexity, on the jazz idiom. Its artists and their themes pepper his works, from bop drummer Max Roach to singer Billie Holiday to (especially) saxophonist Charlie Parker.

This should not be surprising. The entire history of black diasporic art in the United States would be inconceivable without the jazz idiom—it is fundamental, for example, to the paintings of Romare Bearden. Basquiat, however, separates his work on jazz from the idiom's modernist tendencies, which can be heard in the extended compositions of Duke Ellington. His paintings are not driven by modernist concerns with coherent textuality, nor do they uphold the kinds of stable cultural identities traditionally celebrated in Afrocentrism. One need only look at *Charles the First* (1982), a composition Robert Farris Thompson calls "pivotal," to understand this (Thompson, 1995, p. 37). *Charles the First*, a tribute to jazz great Charlie Parker, has no narrative core. Like many of his works, its energy comes from the apt juxtaposition of radically divergent cultural signifiers (e.g., jazz, opera, comic book superheroes). *Charles the First*, in short, does not tell a simple story, nor does it have a singular theme.

As Thompson points out, this is the first of many triptychs (compositions of three panels) that Basquiat would produce. The evocation of the number *3* has played an important role in jazz, most especially in the work of composer Charles Mingus. Mingus opens his 1971 autobiography *Beneath the Underdog* by stating, "In other words, I am three." One is reminded, as well, of his album titles, which include *Mingus, Ah, Um* and *Me, Myself, an Eye*. The word play on Latin conjugation in the former and referentiality in the latter point to the strategies of "triple coding" so much a part of jazz, a music that thrives not as much on original compositions as on "riffs" on the standards. Jazz, as Henry Louis Gates points out, is a music of signifying, a music that explicitly rejects the "original" in favor of constant intertextuality. In fact, Gates links these concerns to the entire history of African American literature in his now-canonical text, *The Signifying Monkey* (1988).

It is this condition of multiple heritages and their open possibilities that the Guyanese novelist Wilson Harris similarly mines in novels such as *The Palace of the Peacock* (1960), *Companions of the Day and Night* (1975), and *Carnival* (1985a). The fusion of the colonized and colonizer subject is at the epicenter of *The Palace of the Peacock*, a novel about the psychological reintegration of opposites in the conquistadorial search for the mythical colony of Mariella, located in the hinterland of Guyana. As the principal character, Donne, and his ill-fated polyglot crew sail up the Cuyuni River in their tortuous journey to reclaim this colony, they discover the subtle and abiding links and associations between each other and the world:

> Cameron's great-grandfather had been a dour Scot, and his great-grandmother an African slave mistress. Cameron was related to Schomburgh (whom he addressed as Uncle with the other members of the crew) and it was well-known that Schomburgh's great-grandfather had come from Germany, and his great-grandmother was an Arawak American Indian. The whole crew was a spiritual family living and dying together in the common grave out of which they had sprung from again from the same soul and womb as it were. They were all knotted and bound together in the enormous bruised head of Cameron's ancestry and nature as in the white unshaved head of Schomburgh's age and presence. (Harris, 1960, p. 39)

Harris's complex genealogy undermines the myth of original subjectivity, the clarity of classical realism as well as the bureaucratic deployment of characterization, and associated traditions of the 19th-century novel. An array of double-coded figures—Harris's "Idiot Nameless" in his *Companions of the Day and Night* (1975), Jorge Luis Borges's Cartographers of the Empire, and the Cuban novelist Reinaldo Arenas's twisted characters who, in the middle of his *Graveyard of the Angels* (1987), announce their dissatisfaction with their lives and ask the author for different roles—all offer alternatives to the bureaucratic deployment of characterization in the European novelistic tradition.

The ultimate argument these authors make is that modern humanity and modern life are necessarily interdependent and deeply hybrid. The underside of modernity and modernization is a quilt, a patchwork of associations, repressed in the philosophies of reason associated with Enlightenment discourses and best exposed through strategies of ambiguity

and double or triple play. These strategies—so central to the work of postcolonial artists—offer educators rich and generative resources to think through contemporary questions about culture. Strategies of double and triple play treat culture less as a sealed-off property than as a ground of possibility and use.

Among others, Derek Walcott has theorized the implications of double and triple coding for educational practice. Reflecting on his own colonial education, he notes, "There was absolutely no problem in reciting a passage from *Henry V* in class and going outside of class and relaxing; there was no tension in the recitation of the passage from *Henry V* and going outside and making jokes in patois or relaxing in a kind of combination patois of English and French." There was, he says, "an excitement that could be shared in both languages at the same time" (as quoted in Baer, 1996, pp. 126–127). We see this excitement reflected in Walcott's work—including his powerful *Omeros* (1990), which reworks Homer's *Odyssey*—as he struggles toward a language that speaks beyond an easy referent to stable identity.

So far, we have looked at both the critique of hegemonic representation and the strategies of double coding that are a central part of the postcolonial aesthetic. These motifs, we argue, are unique to the postcolonial imagination and cannot be subsumed by the three critical traditions with which we opened. We want to look now, more specifically, at how histories of oppression have informed these motifs and how a brutal history of colonialism has necessitated the proliferation of utopian visions that also mark this art.

UTOPIC VISIONS

The third and final theme of the postcolonial imagination we pursue in this chapter is the link between art and emancipatory vision. Postcolonial art is engaged in what C. L. R. James calls in *American Civilization* (1993) "the struggle for happiness" (p. 166). By this James meant the struggle of postcolonial peoples to overcome oppression and glean from everyday life a sense of possibility in a Calibanesque reordering of contemporary social and cultural arrangements. Postcolonial artists link the techniques of aesthetic persuasion to the struggle of Third World people for better lives. They are committed to imagining possibility even when faced with impossible barriers.

In this regard, the paintings of Arnaldo Roche-Rabell, such as *I Want to Die as a Negro* (1993), reclaim and reintegrate the repressed identity of Africa in the Caribbean space. Also worthy of note is Roche-Rabell's *Under the Total Eclipse of the Sun* (1991), in which body parts and human faces seem to rise from the shadowed landscape of the city acropolis. Here we see foregrounded the temporary eclipsing of the power of the United States Congress, which refuses to listen to the voices of the Puerto Rican people.

In a similar manner, Korean artist Yong Soon Min offers viewers a strikingly multilayered installation, "The Bridge of No Return" (1997), in which she explores the parallel realities of the separated peoples of Korea (North and South) and their desires for reintegration across the divides of perspectives and territory (Min, 1997, p. 11). Min foregrounds the deliberately ambiguous nature of her *Bridge* installation as a statement of relationality and interconnectedness but also of in-betweenness and alterity:

> A bridge is, by definition, a connection, fostering relationship between the two otherwise separate sites at either end. A bridge also exists as its own entity, as an interstitial space to be traversed, presumably in both directions. A bridge of one-way passage, of no return, with no connection, no exchange, no continuity, defies the logic of a bridge like an oxymoron. (Min, 1997, p. 11)

The bridge offers a metaphor for the latent connection that courses through the divisions of all races and peoples at the beginning of the 21st century. This latency is also foregrounded in Gordon Bennett's painting *Terra Nullius* (1989), in which he projects the footsteps of the Australian Aboriginal people high above the implanting of the British Union Jack on the Aboriginal landscape in the creation of Australia.

Postcolonial art does not offer the viewer clear solutions to complex problems. Unlike many nationalist art movements (e.g., African American neorealist filmmakers in the U.S. and earlier proponents of Negritude movements, such as Léopold Senghor and Aimé Césaire, in Africa and the Caribbean), this work is marked by contingency, raising questions more than it offers firm solutions. Following Walter Benjamin (1977), these artists forge visions that can sustain and nurture a communal consciousness, if only in qualified and contingent ways. These artists work hard for their momentary victories but are sober enough to realize that struggle is not simple, nor will victory come in one fell swoop. One

is reminded of Gordon Bennett's *Prologue: They Sailed Slowly Nearer* (1988), in which the history of colonial oppression is configured in pop-style pointillism, with British colonizers and aboriginal figures juxtaposed, one on top of the other, complete with comic book–like speech bubbles. Bennett evokes in his style the contingency of historical formations and the possibility of new and different futures.

These works persistently remind us that emancipation has to be built from the bottom up. There is no predictable flow of effects from artistic wish fulfillment, vanguard theory, or even politics to the fruition of social solidarity and the realization of a new community. Writers like Wilson Harris maintain that the new community must be built in the everyday production of difference, cobbled together piece by reluctant piece— only then can the process of dialogue and reintegration of opposites take place. The Palace of the Peacock is Harris's mythical place for the radical encounter between opposites—and it can come into view only in the imaginative work of artists, not in the edicts and *a priori* declarations of theorists and pundits.

Indeed, like the characters in Harris's *The Palace of the Peacock*, we must all give something up, allow our self-interests and crass identities to be scrutinized and perhaps even wrecked in the process of transformation. This is the path of revision and reconciliation that Donne, the rambunctious colonizer and cattle rancher, must go through in the anteroom of the Palace:

> Every movement and glance and expression was a chiseling touch, the divine alienation and translation of flesh and blood into everything and anything on earth. The chisel was as old as life, old as a fingernail. The saw was the teeth of bone. Donne felt himself sliced with this skeleton-saw by the craftsman of God in the window pane of his eye. The swallow flew in and out like a picture on the wall framed by the carpenter to breathe perfection. He began hammering again louder than ever to draw the carpenter's intimate attention. He had never felt before such terrible desire and frustration all mingled. He knew the chisel and the saw in the room had touched him and done something in the wind and the sun to make him anew. Finger nail and bone were the secret panes of glass in the stone of blood through which spiritual eyes were being opened. (Harris, 1960, pp. 102–3)

Donne's turmoil is the turmoil of the contemporary world. It is the turmoil of the colonizer and the colonized, both of whom must endure painful transformation in the search of new possibility, a new home.

One also finds this insistence on the labor of emancipation and the incompleteness of the process of transformation foregrounded in the work of the Barbadian author George Lamming, in novels such as *Season of Adventure* (1960) and *Natives of My Person* (1971). In the latter novel, Lamming reverses the Middle Passage story and tells it through the tortured minds of a colonizer ship captain and his crew, who search for redemption by founding a new, more egalitarian and equitable colony. Lamming adds a further twist to this allegory, however, as the ship, *Reconnaissance,* which is making the triangular trade journey, is mysteriously stalled outside the chosen site of the community, the Island of San Cristobal. In this scenario, the men can only inhabit the island after a rapprochement with their women. Though imagined, emancipation and egalitarian relations are not given. The work of change is where the practice of transformation must truly begin.

As the wife of one of the crew explains, in a somewhat ironic tone, men like her husband must work at collaboration even as they consider altering the fate of others:

> Surgeon's Wife: They would come in the evening. His company. All of the same learning and skill. My husband's house was like a school. Sometimes I would forget the indignities done to me when I saw them in such close collaboration. Discussing prescriptions for every sickness the Kingdom might suffer. . . . I felt they had a wholesome purpose. To heal whatever sickness the Kingdom was suffering. To build a group of New World men. (Lamming, 1971, p. 336)

Emancipation, her monologue suggests, begins not with the creation of a utopian community but with redress to the indignities inflicted within the home space itself.

We point briefly now to a utopian theme raised in the writings of Cornel West (1992) and Gina Dent (1992), namely the link between the work of the imagination and the realization of change. Both West and Dent distinguish between the individualized celebration of incorporated aesthetic work and the vital dynamic of visualizing community. They summarize this distinction in the tension between artistic "pleasure" and communal "joy," a distinction that holds for much postcolonial art. Pleasure is a personal and atomized kind of enjoyment, one that has been explicitly linked to certain kinds of psychoanalytic and filmic cultural criticism. Yet, as noted, postcolonial artists have always seen the self as interwoven with community, making such atomized models entirely untenable.

One recalls here the Kenyan poet Christopher Okigbo's dynamic use of the tension between the private and the public, the individual and the collective, in his collection of poems *Labyrinths* (1971). There is, for instance, an oscillation between anxiety and celebration, desolation and triumph, that produces a cathartic feeling of uncluttered joy at the end of Okigbo's poem "Limits—Fragments out of the Deluge," where he proclaims, "The sun bird sings again." Here the poet links the personal and spiritual triumph over European intrusion to a national and collective African rebirth.

Like Okigbo's poetic narrator, then, postcolonial artists have struggled for "joy," the experience of pleasure in and through collective contexts. Such art takes joy in envisioning new ways for collective struggle, new political possibilities, new ways of being and acting. Artists like Roche-Rabell, Bennett, and Basquiat and writers like Harris, Morrison, and Lamming suggest that this work is not complete. For them the means of struggle is as important, if not more so, than the ends. Transformation cannot be dictated, but is a process in which people work together to build change without the false security of guarantees.

We close with the reflections of Gordon Bennett as he excavates the pedagogical impulses at the heart of his own work:

> If I were to choose a single word to describe my art practice it would be the word *question*. If I were to choose a single word to describe my underlying drive it would be *freedom*. This should not be regarded as an heroic proclamation. Freedom is a practice. It is a way of thinking in other ways to those we have become accustomed to. Freedom is never assumed by the laws and institutions that are intended to guarantee it. To be free is to be able to question the way power is exercised, disputing claims to domination. (quoted in McLean & Bennett, 1996, pp. 10–11)

Bennett clearly evokes a transformative pedagogy here, one that encourages a constant questioning, one that looks beyond laws and institutions and their *a priori* dictates, one rooted in everyday practice. Art is a ground of democratic possibility here.

CONCLUSION

The great effort of the artists whose work we have reviewed is to find the elements that link them and their work to larger communal, national,

and global ecumenical orders. This expansive enterprise, however, is threatened by several pressing dangers.

Specifically, these art forms co-exist with a global culture industry that seeks to commodify them in debilitating ways. Walter Benjamin made this tension exceedingly clear in his classic essay "The Work of Art in the Age of Mechanical Reproduction" (1968), in which he argues that the advent of "mechanical reproduction" both opened art up to wider audiences and used and robbed it of its particular "aura" or air of authenticity. The global circulation of postcolonial art—these novels, paintings, video installations, poems, and songs—has opened up the possibility of unique and compelling dialogues across multiple communities and constituencies.

However, as a parallel phenomenon, many of these artists and their works are being rapidly incorporated into an ever-expanding culture industry. These works thus run the risk of being domesticated, robbed of their emancipatory potential, as they come to serve the imperatives of industry first and foremost. In this regard, we draw attention to the recent film adaptation of Basquiat's life (*Basquiat*, 1996, by Julian Schnabel) as well as Jonathan Demme's 1998 adaptation of Morrison's *Beloved*. Both films dulled the radicalism of the artists and their works by reinstating the same unified subject that Basquiat and Morrison were at pains to critique. We draw attention as well to a growing academic enterprise that would neatly herd these artists into stable disciplines and theoretical paradigms such as multiculturalism and certain kinds of literary postcolonialism.

The rapid circulation of art and aesthetics around the globe thus necessitates a pedagogical intervention. As we have noted, wrestling with the work of art in the postcolonial imagination reveals much that can be useful for pedagogues as they attempt to understand and act upon an increasingly fraught social, material, and cultural landscape. In the next five chapters, we extend these concerns, looking closely at the pedagogies of specific artists. We focus most especially on how educators can look to these artists for more satisfying theorizations of our contemporary moment and its deepest tensions and concerns. We seek to open these texts up to perhaps counterintuitive uses, to allow them to take on new "auras"—new functions and specificities on new terrains.

Postcolonial Critics and Public Intellectuals

Toward a Richer Democratic Dialogue/Redrawing the Boundaries of Disciplined Pedagogy

This chapter's subtitle evokes the work of postcolonial critics and intellectuals in contesting the ever-growing prevalence of "disciplined pedagogies." Disciplined pedagogies do not challenge students to make and remake their worlds, nor do they see students as invested meaning-makers or as partners in fashioning democratic futures. Rather, disciplined pedagogies seek boundary maintenance between areas of knowledge as well as competence and control over subject matter, and seek to foreclose authentic conversation and dialogue and atomize rich, public intellectual life. Sadly, we live in a time when such pedagogies have become the norm, when models for rich and engaged intellectual activity and life are increasingly rare. These restrictive impulses are at work at all levels of the contemporary educational enterprise. For those in elementary, middle, and secondary education, high-stakes testing and accountability measures have become all important, largely circumscribing the role of the teacher as a transformative intellectual. For those of us in higher education, an increasing reliance on adjunct teaching, enrollment-driven resource allocations, assaults on tenure, and corporate "distance learning" initiatives have all conspired against the intellectual freedom once associated with graduate education and the professoriat.

We find ourselves, in the face of this overwhelming circumstance, looking for different models of intellectual life and activity. We focus, in this chapter, on the work of two key public intellectuals, C. L. R. James and James Baldwin. Falling victim to the disciplinary logics discussed throughout, James and Baldwin are displaced to the outside of the traditional purview of postcolonial theory as well as educational thinking. In their work and in their dialogue, Baldwin and James offer an example of collaboration and affiliation that has profound implications for the

36

organization of curricular knowledge and pedagogy. In following the lead of Baldwin and James, we suggest new routes for thinking through our postcolonial moment and its implications for education. We suggest, in particular, a new model for thoughtful postdisciplinary "conversation," an intellectual practice not concerned with sustaining knowledge and genre stratification, nor with scaffolding institutional imperatives, but with transformative and reflective, public intellectual activity.

Baldwin and James, as we will show, foreshadowed many of the current themes of postcolonial theory. Their anticipation of postcolonial thinking is illustrated in the very unfolding of their high-profile, dynamic lives, in their shared patterns of migration, and in their efforts to link local concerns to broader global struggles. But they offer us new and different directions as well. Both were broad in scope in terms of what they studied and the genres they wrote in; both were public, political figures; and both were interested in the complexity of popular representation. These avenues have been foreclosed in much recent work, work that looks at literature or another single art form alone, stresses theory over personal narrative, addresses narrowly defined and circumscribed audiences, and atomizes the role of the intellectual. In their critical reflection on their own lives and the world, James and Baldwin serve as models of thoughtfulness to an educational field bereft of examples of figures like them.

Baldwin and James worked to sustain and regenerate the public sphere during an extended period of time when Cold War politics and racism threatened to close off many avenues of expression and critical thought to intellectuals in general and black intellectuals in particular. As such, they serve as critical exemplars to those of us who might want to rethink the limits of pedagogical practice and the reproduction and regeneration of critical thought in schools and other educational settings.

BALDWIN AND JAMES IN CONVERSATION

James and Baldwin are not normally talked about as contemporaries, in dialogue. The former interrogated the colonial encounter from a Caribbean context and was explicitly aligned with certain strands of Marxism throughout his long career. The latter wrestled with the question of race in the United States during the Civil Rights era. While Baldwin considered economic issues and questions, he was not, by any accounts, a

Marxist (though he flirted very briefly with Marxism early on). Both, however, were part of the same vibrant social milieu in Greenwich Village in the mid-20th century, a milieu that included musicians, writers, poets, painters, and intellectuals.

Documentation on the relationship between James and Baldwin is spotty. However, it is clear that James used to frequent a Caribbean restaurant, the Calypso, where Baldwin worked as a waiter. This restaurant played a large part in Baldwin's life, and he described it in stunning detail in his semi-autobiographical novel, *Tell Me How Long the Train's Been Gone* (1968). He writes,

> Of course, our emphasis was very heavily on the islands, mightily exotic—this may have helped; and we anticipated, if we didn't indeed help to create, the Calypso craze that was shortly to sweep the nation. Negro entertainers, working in Village clubs, very often dropped in, and this gave the place a certain "tone," a certain vibrance, and they sometimes, if the spirit so moved them, sang or danced. (p. 368)

As James tells it, writing for the *Sunday Observer*, Baldwin was young when they knew each other. "Baldwin, a boy of about 19, used to come there [the Calypso] and listen to the talk of the literary and political men. Rarely he would join in, always conscious (as I thought) of his youth, but, I know now, also conscious of his own independent ideas" (James, 1966, p. 7). In turn, Baldwin described James in a lecture at Yale (1983), the Fifth Richard Wright Lecture, as a key influence on him but noted that he was little known in the United States.

Baldwin and James also knew each other through literary giant Richard Wright and used to gather at his house on Charles Street in Greenwich Village. In fact, Baldwin's critical essays on Wright would become a point of contention between Baldwin and Constance Webb, James's ex-wife and Wright biographer. Webb, once friendly with Baldwin, resented him for what she perceived as unfair critiques of Wright and implied that Baldwin willfully misread him in such essays as "Many Thousands Gone" and "Everybody's Protest Novel" (C. Webb, letter to N. Cousins, April 29, 1963). However, many years later, she would ask Baldwin to write an introduction to a volume of correspondence between James and herself. In her letter to Baldwin, she mentioned the "days when we met at Dick's [Wright's] house on Charles Street" and also noted, "Although much younger than Nello [James], you more

than anyone remember the atmosphere of those days in the Village and on Charles Street" (C. Webb, letter to J. Baldwin, January 15, 1987).

Baldwin was introduced to his employer Connie Williams, the Trinidadian owner of the Calypso, by the painter Beauford Delaney. Baldwin had an intense, life-long relationship with Delaney and has written often of his first visit to his studio. Beauford was, Baldwin (1985b) writes, "the first walking, living proof, for me, that a black man could be an artist" (p. xi). Delaney's paintings—wrestling with the representational techniques of modernism while portraying the everyday experiences of African Americans—provide a compelling counterpart to Baldwin's own often baroque prose.

Baldwin recalled numerous times the visual images that struck him when he first entered Delaney's studio—the striking paintings set against the sharp white walls. However, he also simultaneously recalled the ever-present music. He writes,

> I walked into music. I had grown up with music, but, now, on Beauford's small black record player, I began to hear what I had never dared or been able to hear. Beauford never gave me any lectures. But, in his studio and because of his presence, I really began to *hear* Ella Fitzgerald, Ma Rainey, Louis Armstrong, Bessie Smith, Ethel Waters, Paul Robeson, Lena Horne, Fats Waller. (1985b, p. x)

Greenwich Village in the middle of the century was a vibrant milieu in which painters, musicians, and intellectuals were in constant dialogue with each other across aesthetic, geographic, and political lines. The richness of this dialogue is easily lost in the "great man" narratives that tend to get constructed from within individual disciplines.

James and Baldwin also shared important similarities in their thinking. Both, for example, shared long histories of migration, histories that came to define, in large measure, their careers and perspectives. James was born in Trinidad and then moved to London, where he became involved with the Independent Labor Party. He then traveled to the United States, where he continued his political work before returning to London due to an expired visa. His political and aesthetic interests were indeed deeply connected to travel—to England, Mexico, Africa, the Caribbean, and the United States. In this sense, James functioned as a postcolonial commentator whose theater of action was the contemporary world, writing intensely about the fortunes of revolution and mass struggle in Europe, Africa, and North America. For James, the United States

was a peculiar social context, one where people were encouraged to struggle intensely for individual happiness, but where the individual was every day more deeply incorporated into the deadening machinery of industry and the depersonalizing orders of modern bureaucracy. These processes, which the sociologist Max Weber elaborated upon in the early part of the 20th century, were inextricably intertwined and very much a part of popular culture in the United States. Plainly, like de Tocqueville before him, James's encounter "abroad" was a defining one, culminating in the volume that was published posthumously under the title *American Civilization* (1993). The book documented various aspects of modern life in the United States through close readings of literature (like *Moby Dick*), as well as film, television, and radio. These popular arts all had a place in the "struggle for happiness" (p. 166) that James saw at the center of life in this country.

Baldwin, in turn, was born in Harlem, but traveled to Paris, Switzer-land, the south of France, and Algiers, where he did much of his most compelling work. He considered himself an expatriate and referred often to this condition in his fiction and nonfiction. Paris was central to the formulation of his expatriate identity, as evidenced by essays such as "Equal in Paris" (1955b) and novels such as *Another Country* (1962). Indeed, many of Baldwin's most famous and powerful essays, including "Stranger in the Village" (1955d), were written outside the United States, and like many, Baldwin used this perspective to gain a focus on his own situation "back home." Baldwin blurred the lines between home and exile, commenting in an important lecture (Baldwin, 1983) that his trips abroad gave him the courage and critical apparatus to visit another seemingly foreign country—the American South.

Both Baldwin and James thus shared histories of migration, and both made explicit efforts to link local issues to a global perspective. Both writers, to echo Hall, problematized the "here" in light of the "there." Similarly, postcolonial theory today attempts to contest the neat boundaries between different cultural contexts (see Appadurai, 1996; Bhabha, 1994; Clifford, 1997). Culture itself is not localized but profoundly and inextricably part of global flows—profoundly and inextricably hybrid. This is a very significant insight for educators as they struggle with the culture wars over canon formation and multiculturalism. What these writers point us toward in the expression of their own lives is the need for a critical and dispassionate attitude toward cultural origins. Baldwin and James pursued a rigorously critical attitude to the cultural forms

produced by the members of their own cultural group (for example, Baldwin [1955b] on Richard Wright) and a zesty open-mindedness in their revision of received ideas (James [1993] on the impact that his sojourn in the United States had on his sense of identity and his affiliation to the Caribbean and to England) as they worked to negotiate the meanings of the new political and social contexts into which they kept throwing themselves.

One can see this rigorous openness in both men's Pan-Africanist perspective on black struggle, especially vis-à-vis the Civil Rights movement in the United States. While for James the Civil Rights movement had a vitality and an autonomy of its own and an organic intellectual and political perspective, he linked black struggle in the United States to a global reality, to liberation struggles in Africa, the Caribbean, and Asia. He saw the new social movement of the black masses along with the struggle of women as directly linked to the international workers' struggle and to political and social developments in Western industrialized societies.

Baldwin too linked the question of struggle in the United States to global struggles for black independence. Baldwin's trips to France, where he was able to see how similar kinds of colonial oppression affected the lives of Algerian immigrants, were extremely instructive in forming his own globalized social and political vision. In some sense, he stressed, all colonizers share something vital, as do all colonized people. He writes, in *No Name in the Street* (1972),

> Any real commitment to black freedom in this country would have the effect of reordering our priorities, and altering our commitments, so that, for horrendous example, we would be supporting black freedom fighters in South Africa and Angola, and would not be allied with Portugal, would be closer to Cuba than we are to Spain, would be supporting Arab nations instead of Israel, and would never have felt compelled to follow the French into Southeast Asia. (p. 178)

These struggles were intertwined for Baldwin, as they were for James.

In short, both writers defied localized thinking. Both also defied disciplinary thinking. James was a playwright ("The Black Jacobians," 1992a), a novelist (*Minty Alley*, 1936), a short story writer ("La Divina Pastora," 1992b, and "Triumph," 1992c), a social critic (e.g., *American Civilization*, 1993), and a critic of music, painting, poetry, and literature (e.g., the essays "Three Black Women Writers: Toni Morrison, Alice

Walker, Ntozake Shange," 1992d, and "Picasso and Jackson Pollock," 1992e). He was perhaps best known for his work on the sport of cricket (*Beyond a Boundary*, 1963). In turn, Baldwin was a novelist (e.g., *Another Country*, 1962, and *Giovanni's Room*, 1956), essayist (e.g., *The Fire Next Time*, 1963), poet (*Jimmy's Blues*, 1985a), playwright (*The Amen Corner*, 1965, and *Blues for Mister Charlie*, 1964), film critic (*The Devil Finds Work*, 1976), and screenwriter (*One Day When I was Lost*, 1973).

Neither Baldwin nor James made the kind of disciplinary distinctions that mark so much writing in the academy today, where scholars have tended to isolate themselves within one area of expertise, say, literature or education. We have linked these isolationist tendencies elsewhere to a growing tide of ressentiment in the academy, a kind of professionalization that short-circuits the enormous critical and intellectual energies circulating around issues of race, identity, and representation today (McCarthy & Dimitriadis, 2000). Much of this work has been explicitly depoliticized as well. As Hall points out, the lack of explicit political and economic analysis is striking in the "postcolonial" discourse. As he writes, "The 'postcolonial' has been most fully developed by literary scholars, who have been reluctant to make the break across disciplinary (even post-disciplinary) boundaries" and explore other kinds of issues (1996, p. 258).

James and Baldwin both worked in multiple genres and addressed multiple audiences in multiple sites. Both were public intellectuals in the clearest sense, intellectuals who linked their own biographies and experiences to the most pressing contemporary issues, mobilizing diverse audiences in unpredictable ways and using domains outside of formal education (novels, journal articles, short stories, public meetings, church sermons) to conduct a pragmatic education of the mass public. James ceaselessly ruminated on the fate of the relationship between the intellectual and the masses in the modern world, an issue similarly important to African American intellectuals such as Angela Davis and Malcolm X. For James, the intellectual is not simply an academic or an expert ensconced in the safety of the ivory tower; the intellectual is a transformative social subject committed to a particular articulation of the classed, raced, and gendered interests, the needs, desires, and aspirations of embattled social groups. The intellectual straddles the contradiction of the world of the private, solitary practice of scholarship and the public world of the embattled masses, their popular imagination and their popular will. James's work highlights the constant movement between these poles of separa-

tion and affiliation, especially in his autobiographical writings and his personal correspondence and letters (James, 1996).

James's political activism is worth stressing here. James not only helped to make the case for West Indian independence, he was also a founding member of the Pan-Africanist Movement in the United States and England. He was deeply engaged in British labor politics, and collaborated with Trotsky while the latter was exiled in Mexico. James saw these sites of radical work as deeply integrated. James thus demonstrates how intellectuals can connect with the public by drawing together the personal and the political. His *Beyond a Boundary* (1963), in particular, was a struggle to link the autobiographical to the popular, the agonistic private to the turbulent public, the high to the low.

Baldwin's work evidences similar concerns, also drawing on the details of his own life. Baldwin used his life as a resource—one he could draw on in the always uncertain task of speaking to broad, multiple constituencies, building empathy while never settling for what Patti Lather calls "comfort texts" (Lather, 1997, p. 286). His life was filled with paradoxes and complexities. Among other things, he was black, gay, heavily influenced by the Baptist church, a (willing or not) spokesperson for African Americans, an artist struggling with existential demands—paradoxes he continually used to challenge himself and his readers.

Baldwin registered the complexities of his own life in order to get at the social and psychological dynamics of racial antagonism in the United States and around the globe. He took great pains to talk about the signs and symbols that undergird everyday life, signs and symbols that organize our lives in entirely unfair ways. He writes, for example, of how in the South, the "system of signs and nuances covers the mined terrain of the unspoken—the forever unspeakable—and everyone in the region knows his way across the field" (1985c, pp. 215–216). With great sensitivity, Baldwin linked the subtle social, psychological, and sexual dynamics around him to his own highly visible anti-racist political project. Baldwin was frequently interviewed, appeared on the cover of *Time*, went on a speaking tour for the Congress of Racial Equality (CORE), worked with Medgar Evers to investigate lynching in the South, worked with the Student Nonviolent Coordinating Committee (SNCC) on voting drives for poor blacks, and was called upon by politicians including Robert Kennedy to discuss racial issues and tensions in the United States.

James's and Baldwin's concern with broad, public communication registers in another key common interest—popular culture. James's most

notable work on popular culture is his essay "Popular Arts and Modern Society," collected in *American Civilization*, while Baldwin's is his collection on film, *The Devil Finds Work* (1976).

For Baldwin, music and film were both "hieroglyphics," cultural signs that were inscrutable yet filled with meaning, telling painful and conflicting tales that did not find easy resonance in language itself. In a passage from "Many Thousands Gone," he notes:

> As is the inevitable result of things unsaid, we find ourselves until today oppressed with a dangerous and reverberating silence; and the story is told, compulsively, in symbols and signs, in hieroglyphics; it is revealed in Negro speech and in that of the white majority and in their different frames of reference. The ways in which the Negro has affected the American psychology are betrayed in our popular culture and in our morality. (1955c, p. 24)

Baldwin made many attempts to decode these "hieroglyphics" by interrogating his own life, especially in his book on cinema, *The Devil Finds Work* (1976). When discussing the film *In the Heat of the Night* (1967), he comments on "the anguish of people trapped in legend. They cannot live within this legend; neither can they step out of it" (1976, pp. 55–56). These legends are bigger than any one person, but they do not let anyone get beyond them. We are doomed to live in and through them, speaking as they do to the deepest tensions that inhere in the particular American colonial encounter.

James's work serves as a compelling counterpart to Baldwin's here. When James first came to the United States, he was struck by the peculiarly American paradoxes that inhere in popular art. He starts with a very basic proposition—that popular art is the site where the most relevant contemporary artists speak most clearly to engaged constituencies about the nature of modern life. James writes,

> The modern popular film, the modern newspaper (the *Daily News*, *not* the *Times*), the comic strip, the evolution of jazz, a popular periodical like *Life*, these mirror from year to year the deep social responses and evolution of the American people in relation to the fate which has overtaken the original concepts of freedom, free individuality, free association, etc. To put it more harshly still, it is in the serious study, above all, of Charles Chaplin, Dick Tracy, Gasoline Alley, James Cagney, Edward G. Robinson, Rita Hayworth, Humphrey Bogart, genuinely popular novels like those

of Frank Yerby...men like David Selsnick, Cecil deMille, and Henry Luce, that you find the clearest ideological expression of the sentiments and deepest feelings of the American people and a great window into the future of America and the modern world. This insight is *not* to be found in the works of T. S. Eliot, of Hemingway, of Joyce, of famous directors like John Ford or Rene Clair. (1993, pp. 118–119)

Looking at popular culture over time, "from year to year," helps us trace many of the most important dynamics at the heart of American social and cultural life, an insight Baldwin underscores in his reflections on hieroglyphics.

James locates popular culture at the heart of the deepest paradox about American life: that as more and more people are brought into modern, routinized, industrialized life, they are offered more potentials for individual realization, potentials that are continually thwarted by these same rationalizing structures. He writes:

It is clear that in the modern mechanized collectivized world, with its building up on the one hand of all sorts of possibilities and vistas for the individual personality, and on the other its confinement of the personality to a narrow routinized existence with the mechanical means, there arises the need to realize the thwarted possibilities or certain parts of them through some symbolic personality. (1993, p. 147)

These thwarted possibilities find their realization in the "symbolic personalities" of Hollywood. James focuses here on the characters of the gangster and the renegade detective, both of whom operate outside the deadening bureaucracies of American law and order. Though on opposite sides of the law, they are more similar than not. He writes,

Law and order must be preserved—and the gangster has been transformed into a private detective. But this detective is in reality the same character as the gangster. He uses what methods he can, he is as ready with his gun-butt or a bullet as the gangsters. *Both have a similar scorn for the police as the representative of official society.* (1993, p. 124)

It is in the gangster or a detective like Sam Spade that we see emerging the resentful individual—the middle-class male. These detectives were exemplars of ressentiment and purveyors of the vengeful morality of American society's frustrated professional middle class. According to Jeff Schmidt (2000), this class is characterized "by cynicism, disconnection,

loss of vitality and authenticity, decreased enjoyment of family life, anger
. . . social isolation and loneliness" (p. 2). The central targets of its res-
sentiment were the socially and culturally deviant, society's poor and un-
derclass—figures represented in the powerful social trope of the gang-
ster. And thus we have the peculiar drama that gets played out for
seemingly insatiable audiences, across generations, year after year.

Baldwin, like James, had a particular fascination with popular arche-
types like the gangster and took up very similar concerns as did James—
evidencing, once again, the broad dialogue and conversation in which
they were engaged. In *The Devil Finds Work* (1976), Baldwin discusses
gangster films such as *Dead End* (1937) and *The Godfather* (1972). The
gangster has been a constant source of fascination for both black and
white audiences—from *Angels with Dirty Faces* (1938) and *The Godfa-
ther* to *Superfly* (1972) and *Menace II Society* (1993). In fact, Baldwin
says that "*le gangster*" and "the *nigger*" have a similar place in the popu-
lar American imagination, both marginalized and fetishized, an insight
that helps explain the phenomenal commercial success of contemporary
"gangsta rap" (1976, p. 23).

Yet, like James, Baldwin uses autobiography to extend his analysis,
articulating these filmic representations with his own experience of mar-
ginality. While discussing the film *Dead End*, he notes that he has known
many people similar to the gangster that Bogart plays, "with his one-
hundred dollar suits, and his silk shirts, and his hat." However, he criti-
cizes the film for its lack of broader human context. The heroine, he
notes, seemed all too innocent:

> the severity of the social situation which Dead End so romanticizes . . .
> utterly precludes the innocence of its heroine. Much closer to the truth
> are the gangster, his broken mother, and his broken girl—yes: I had seen
> *that*. The script is unable to face the fact that it is merely another version
> of that brutal fantasy known as the American success story: this helpless
> dishonestly is revealed by the script's resolution. (1976, pp. 26–27)

This narrative, this "legend," fails to account for the sadder and more
complex picture. Indeed, the very neatness of the plot's resolution hints
at the harsher reality it works to silence. Commenting on his response
to the main character's decision to turn in the gangster, Baby Face, he
writes,

> I was by no means certain that I approved of the hero's decision to
> inform on Baby-Face, to turn him over to the police, and bring about his

death. In my streets, we never called the cops, and whoever turned any-
one into the cops was a pariah. I did not believe, though the film insists
on it, that the hero (Joel McCrea) turned in the gangster in order to save
the children. I had never seen any children saved that way ... I could
believe—though the film pretends that this consideration never entered
the hero's mind—that the hero turned in the gangster in order to collect
the reward money: that reward money which will allow the hero and the
heroine to escape from the stink of the children: for I had certainly seen
attempts at *that*. (1976, p. 27)

He goes on to note that "even with some money, black people could
move only into black neighborhoods: which is not to be interpreted as
meaning that we wished to move into white neighborhoods. We wished,
merely, to be free to move" (1976, p. 28).

There are no "good guys" and "bad guys" in Baldwin's world.
There is no recourse to a "happy ending." As with James, we have only
his attempt to decode these key "hieroglyphics" by drawing on his own
autobiography. The result is a narrative that is political as well as per-
sonal—his own experience seeing the movie *Dead End* intertwined with
a discussion of cultural autonomy, integration, and the paradoxes of
white authority. Throughout, he relies most clearly on his own experi-
ences, experiences that constantly worked with and against these popular
representations, experiences that spoke to the ways we are all situated
inescapably in history. Throughout, he critiqued "that brutal fantasy
known as the American success story" with a unique, embodied social
vision.

C. L. R. James and James Baldwin thus serve as counterparts to each
other. Both focus on popular culture and its "hieroglyphics" as key sites
for understanding the contemporary social and cultural moment. Both
use their own stories as resources. Popular culture, as George Lipsitz
(1990) argues, is a profoundly dialogic realm where different versions
and visions of history fight to be accepted as common sense. Both Bald-
win and James entered this messy and problematic realm *tout court*, re-
fusing to abdicate its complexity for safer shores.

CONCLUSION

"The purpose of education," Baldwin wrote, "is to create in a person
the ability to look at the world for himself, to make his own decisions.

. . . To ask questions of the universe, and then to learn to live with those questions, is the way he achieves his own identity" (1988, p. 4). Indeed, societies can function only when engaged citizens continually question their circumstances, continually make and remake themselves and their worlds. Yet there is a paradox here, as "no society is really anxious to have that kind of person around. What societies really, ideally, want is a citizenry which will simply obey the rules of society. If a society succeeds in this, that society is about to perish" (p. 4). If current trends in education continue—trends toward strict accountability measures, high-stakes testing, and the de-skilling of teachers—we are in danger of producing a disciplined citizenry that cannot sustain rich, democratic life. We are in danger of fostering "disciplined pedagogies" that will teach young people only to obey rules—not to fashion different kinds of futures. The work of Baldwin and James, however, offers us a new way to think about what pedagogy might mean. We see a pedagogy that is enmeshed in individual biography, exceeds the concerns of particular disciplines, engages with the popular, links the local with the global, and is intensely concerned with social change. We see a pedagogy that yearns for authentic, deliberative conversation that stretches beyond school walls and looks toward a broader theater of action. James and Baldwin collapse distinctions between art, criticism, and pedagogy, giving educators a broader range of resources for re-imagining and re-visioning their vocations.

Wilson Harris and the Pedagogy of the Carnivalesque

As we noted in our introduction and in the previous chapters, the dynamics of multiplicity and difference brought on by globalization, mass migration, and electronic media have increasingly begun to challenge dominant curriculum and pedagogical practices that insist on an imposed homogeneity and intellectual insulation from the teeming world of cultural and social differences outside the school. We have argued, further, that in contrast postcolonial artists have directed our attention to this sense of multiplicity as a potential model of ethical change that releases a deep-bodied problematization of our taken-for-granted sense of reality and the imagined social relations we have with each other and with our social world as a whole. This chapter continues to explore the topic of multiplicity by examining the treatment of the theme of the carnivalesque, or the radical relativizing of inherited roles, traditions, styles, knowledges, and space in the writing of postcolonial novelist Wilson Harris (Henry, 2000).

The carnivalesque—its significant contributions to the rise of the public sphere, its celebration of anti-hierarchical peasant worldviews, its anti-modernism and anti-capitalism moment, its sublimation in literature, and its associated participation in the rise of a heterological literary voice—has been addressed by a number of social, cultural and literary theorists, such as Tony Bennett (1995), Peter Stallybrass and Allon White (1986), and of course, Mikhail Bakhtin (1984). In talking about "the characteristics of genre" in his *Problems of Dostoyevsky's Poetics*, Bakhtin (1984) maintains the following about the carnivalesque as a cultural and political form:

> Carnival is a pageant without footlights and without a division into performers and spectators. In carnival everyone is an active participant, everyone communes in the carnival act . . . The laws, prohibitions, and restrictions that determine the structure and order of the ordinary, that is noncarnival, life are suspended during carnival: what is suspended

first of all is hierarchical structure and all the forms of terror, reverence, piety, and etiquette connected with it—that is, everything resulting from socio-hierarchical inequality or any other form of inequality among people.... All *distance* between people is suspended, and a special carnival category goes into effect: *free and familiar contact among people.* (pp. 122–123)

For Bakhtin, the carnival inverts the hierarchies, structures, prohibitions, and restrictions that atomize public life. In the carnival, the "order of the ordinary" is suspended. New social orders and modes of association proliferate, and "free and familiar contact among people" reigns.

Only recently, however, have scholars shifted their focus from European to postcolonial carnivalesque practices. In this chapter, we join with an emergent set of voices exploring postcolonial carnivalesque practices. These writers include Paget Henry (2000), Homi Bhabha (1994), Michael Dash (1990), Sandra Drake (1989), and Russell McDougall (1989). In the literary works of Third World writers, we are interested in how the carnivalesque discourse generates a new subaltern subjectivity at the epicenter of the novel form, whose deconstruction by postcolonial writers we discussed earlier. We look at postcolonial literature as a space for the exploration of difference, not as a problem, but as an opportunity for a conversation about establishing a normative basis of communicative action in education. Such a dialogue might get us beyond the roadblocks of cultural balkanization and disciplinary confinement that now dominate so much of educational life. Postcolonial literature's redeployment of the vocabulary of difference might help us humanize an increasingly commodified, instrumental, and deeply invaded curriculum field. An exemplar of this new carnivalesque humanism is the work of the Guyanese novelist Wilson Harris. We look at his novels *Carnival* (1985a) and *The Palace of the Peacock* (1960), highlighting in particular his infusion of play in the very organization of knowledge and his reevaluation of difference.

WILSON HARRIS, SCHOOL LIFE, AND THE FRACTURED SELF

Harris, like many of the artists we discussed, has a fairly complex family history. Harris was born in New Amsterdam, British Guyana, in 1921, of mixed parentage—Amerindian, European, and African. Such diversity was not at all uncommon in Guyana, and Harris would be deeply in-

formed by the nation's multiracial and multi-ethnic makeup. His work would fundamentally define itself against all manner of social and intellectual parochialism and essentialism. According to the *Cambridge Guide to Literature in English*, Harris's "free-ranging, non-logical, highly metaphoric, associative techniques in prose derive from a poetic imagination fired intellectually by extensive reading" in philosophy, anthropology, and folk mythology (Ousby, 1988, p. 437). Harris attended Queen's College, Georgetown. After leaving school, he worked as a surveyor for the government, often traveling to the interior of Guyana to construct maps and conduct geological studies. The experience was formative. Visually, Harris's writing is energized by the Guyanese savannas, powerful river currents, and swirling rock strata. In *The Palace of the Peacock* (1960), *The Far Journey of Oudin* (1961), *The Whole Armour* (1962), and *The Secret Ladder* (1963), published as *The Guyana Quartet* (1985b), Harris uses the physical landscape as metaphor, even allegory, for the workings of the human psyche and its capacity to resist ossification.

In what follows, we focus on a new subject identity introduced in Harris's novels: a twin or double figure of reversible sensibility and feeling, neither colonizer nor colonized but both—a shadow and a mask rising from the flotsam, detritus, and ruins of colonial historical realities. This figure is an allegorical trope for the new society, the new dispensation, the new epiphany. How might we understand this new subject in light of the carnivalesque? And what broad implications does Harris's deployment of the same have for curriculum and educational change?

We see Harris's work as profoundly important for thinking through contemporary trends and pressures in education and especially multicultural education today. As Michael Apple (1993), among others, has made so very clear, educators are facing accelerating pressures of standardization and professionalization. "At the local, state, and national levels," he writes, "movements for strict accountability systems, competency-based education and testing, management by objectives, a truncated vision of the 'basics,' mandated curricular content and goals, and so on are clear and growing" (pp. 121–122). The role of the teacher as a transformative intellectual has been increasingly circumscribed by these imperatives.

Apple relates these concerns to a broader and longer history of management's rationalizing and standardizing people's work (1993, p. 120). He sees two major consequences of these twin imperatives, both of which have come to mark the field of education today.

The first is what we shall call the *separation of conception from execution*. When complicated jobs are broken down into atomistic elements, the person doing the job loses sight of the whole process and loses control over her or his own labor since someone outside the immediate situation now has greater control over both the planning and what is actually to go on. The second consequence is related, but adds a further debilitating characteristic. This is known as *deskilling*. As employees lose control over their own labor, the skills that they have developed over the years atrophy. They are slowly lost, thereby making it even easier for management to control even more of one's job because the skills of planning and controlling it yourself are no longer available. (1993, p. 121)

The role of the teacher has been increasingly narrowed and circumscribed by these emerging processes, less and less tied to individual student and teacher biographies, interests, dispositions, and so forth. Education becomes a kind of normative science on this logic, one that aims for a totalizing vision and control over knowledge, and that robs teachers of their calling as transformative intellectuals.

Apple's analysis regarding the loss of teacher autonomy is extended in the work of Jeff Schmidt (2000), who sees teachers as a part of a general class of professionals of the "disciplined mind" who have sold their souls to modern institutions for a salary. They live a double life in which their humanity is repressed and a hard calculating nature now dominates them and the work they do, as a matter of survival. Schmidt maintains that educational professionals especially have lost control over the nature of their work and are rendered mere functionaries, hostile to difference and creativity in the educational setting. He further insists that educators are disciplined by the whole process of educational preparation and hierarchical structure that regulates the use of their labor power. Professors, he maintains, symbolize the tragedy of all employed professionals who started out as students loving their subjects. Such students submit themselves to the process of professional training in an effort to be free of the marketplace, but instead of being strengthened by the process, they are crippled by it. Deprived of political control over their work, they become alienated from their subjects and measure their lives by success in the marketplace (p. 146).

As we have argued elsewhere (McCarthy & Dimitriadis, 2000), multicultural education today has become just such a science of professional training—a discipline of difference in which the matter of cultural

alternatives has been effectively displaced as a supplement and dovetails similarly with corporate logic. Frustrated by the professionalization of multicultural education, we look to postcolonial literature for new ways of mediating the complexity and plurality that now define modern life, but that are subordinated in schools and other contemporary institutions. In this emergent literature, we seek out sources of alterity that might work against the grain of educational normalization. Harris elaborates an aesthetics of existence that strives toward a broader and more invested kind of encounter between human actors. Such an encounter is a paradigm for a new pedagogical model that involves teachers and students in authentic dialogue across difference, that does not aim at competency, control, and ossification but that makes each member of the dialogue, in Freire's sense, responsible for the humanity of the others. We see the notion of the carnival as having some purchase here, in foregrounding the decentered and porous subject necessary for such an encounter.

Beyond Realism: Wilson Harris and the Postcolonial Novel

Drawing on Bakhtin's insights, McDougall (1989) focuses attention on the literary appropriation of the carnivalesque and its radical effects on the novel. For McDougall, carnivalesque fiction tends to be distinguished by the following features: 1) satire, parody, laughter, and extraordinary inventiveness of plot; 2) Socratic settings of truth and discovery in dialogue; 3) inserted genres of philosophical speculation, oratorical speeches, and other normatively "nonfictional" discourses; 4) a mock-heroic protagonist whose experiences and adventures are presented as an allegorical explorations of a larger system of political or cosmic forces; 5) characters who are in a constant state of flux, fragmentation, or decomposition; 6) reversibility of fiction in which characters' fortunes and roles are as interchangeable as a set of masks; and 7) cumulatively, a peculiar sense of doubling or mirror distortion of the polyglot characters that inhabit the novel.

All of these elements of the carnivalesque literary genre are substantively present in Wilson Harris's work. Harris's own writing proceeds from an acute desire to decode, disassemble, and reconstruct the classical realist 19th-century novel genre. His is a radical impulse to shatter the 19th-century novel's self-security, its privileged discourse, and its pretensions to objective or foundational truth. The classical realist novel, as

Harris (1967) notes in his *Tradition, the Writer, and Society*, proceeds along a path of consolidated biases and prerogatives. It insists on a free-standing individual character or protagonist at the center of events, conflicts, tradition, or change. Harris indicates his own departure from the realist novel in the following:

> The consolidation of character is, to a major extent, the preoccupation of most novelists who work in the twentieth century within the frame-work of the nineteenth-century novel. Indeed the nineteenth-century novel has exercised a very powerful influence on reader and writer alike in the contemporary world. And this is not surprising after all since the rise of the novel in its conventional and historical mould coincides in Europe with states of society which were involved in consolidating their class and other vested interests. As a result, "character" in the novel rests more or less on the self-sufficient individual—on "elements of per-suasion" (a refined or liberal persuasion at best in the spirit of the phi-losopher Whitehead) rather than "dialogue" or "dialectic," in the pro-found an unpredictable sense of person which Martin Buber, for example, evokes. (1967, pp. 28–29)

Harris goes on in the same essay to make an even more specific indict-ment of the realist novel:

> The novel of persuasion rests on grounds of apparent common sense: a certain "selection" is made by the writer, the selection of items, man-ners, uniform conversation, historical situations, etc., all lending them-selves to build and present an individual span of life which yields self-conscious and fashionable moralities. The tension which emerges is the tension of individuals—great or small—on an accepted plane of society we are persuaded has inevitable existence. (1967, p. 29)

Harris believes that the freedom that the individual is allowed in the realist novel is ultimately illusory—an elaborate form of what the Frank-furt cultural critic Theodor Adorno calls "false clarity." The novel of consolidation or persuasion is an inadequate aesthetic vehicle for the hy-brid form of postcolonial subjectivity. As Harris argues, "What in my view is remarkable about the West Indian [or the postcolonial subject] in depth is a sense of subtle links, the series of subtle and nebulous links which are latent within him, the latent ground of old and new personali-ties" (p. 28). Harris (1967) argues for a revolution in the form of the novel that would connect existing postcolonial communities to "their

variable pasts" (p. 31). These variable pasts are not the separated histori-
cal origin stories of particular ethnic groups, nor the fixed cultural prop-
erty of 21st-century nations and races. Instead, Harris insists that cultural
traditions are gateways of unsuspected association and cultural connec-
tion between all past and contemporary people—a theme we will pick
up in the next chapter.

Instead of the strategy of "consolidation" or persuasion, then, Har-
ris foregrounds a new task or orientation for the postcolonial novel. He
offers one word to describe the new career of the novel—"fulfillment."
In his artistic imagination, the novel of "fulfillment" is a polysemic text
that privileges contradiction and incompleteness. Yet for Harris, incom-
pleteness is more than the narcissistic desire of the self for the other, in
which both self and other remain discrete. Instead, Harris breaks down
any unity of position by producing a kind of fiction that "seeks to con-
sume its own biases through the many resurrections of paradoxical imagi-
nation" (1960, p. 9). This self-consuming and regenerating novel inau-
gurates an alternative to the Hegelian dialectic of master and slave,
dominator and dominated—an ultimately one-dimensional model of
power and communication.

We have moved beyond what Hommi Bhabha calls "the transpar-
ency of power," and we have now entered the twilight zone of the
hybrid. Hybridity is not cultural diversity or some racial admixture of
some fortuitously agreeable elements. Instead, it is a radical disturbance
of both "self" and "other," an encounter that leads ultimately to unan-
ticipated, maybe even unspeakable, transgressions. Bhabha (1994) is
helpful:

> Hybridity is the sign of the productivity of colonial power, its shifting
> forces and fixities; it is the name for the strategic reversal of the process
> of domination through disavowal (that is the production of discrimina-
> tory identities that secure the "pure" and original identity of authority).
> Hybridity is the revaluation of the assumption of colonial identity
> through the repetition of discriminatory identity effects. It displays the
> necessary deformation and displacement of all sites of discrimination
> and domination. It unsettles the mimetic or narcissistic demands of co-
> lonial power but reimplicates its identifications in strategies of subver-
> sion that turn the gaze of the discriminated back upon the eye of power.
> (p. 112)

What Bhabha suggests is that the colonial encounter is not repressive
but productive of all kinds of effects the colonizer did not anticipate,

lively distortions of the colonizing culture that leave their traces in skin tones, colloquialisms, hybrid musics, spiritual practices, and foods. The postcolonial novel is born in the crucible of cultural modernization, not in the purported pure space of premodern folk origins and the associated auratic art before the advent of cultural commodification. We will take on this notion of "the folk" more clearly in Chapter 5.

Harris tells the story of the hybrid postcolonial subjects of the New World: the half-made, broken individuals strewn among the melancholy historical ruins of empire who mediate the gateway between the Old World and the New, the West and the non-West. Harris is interested in exploring the palpable tensions between overlordship and dependency, the mutual desires and transgressions of the self and the other, and the very fragility of normative structures as they are inscribed in society and in the novel. He is interested in the reversal of hierarchical systems and in the subversion of absolute powers in the production of meaning—in the novel form and, by extension, the classroom. Harris mines the subversive capacities boiling underneath the surface of language itself. He puts into play new categories of meaning that allow his characters to cross the zones of confinement, alienation, and difference. His characters are Old World and New World, female and male, ethnically ambiguous and androgynous. They are the half-made apostles of a new dispensation—the traumatized inhabitants of a postmodern/postcolonial world, somehow thriving after the holocaust of colonization.

Carnival and the Life and Death of Everyman Masters

We now turn to a more detailed discussion of Harris's novels. The principal protagonists in Harris's *Carnival* and *The Palace of the Peacock* are Everyman Masters and Captain Donne, respectively. They are paired with narrator-biographers who seem to be so compelled by the lives, adventures, and associative worlds of their elusive subjects that the narrators lose themselves again and again in the stories that they seek to record. In *Carnival*, it is difficult at times to tell Everyman Masters from John Weyl, his narrator, who becomes Masters's double and ultimately lives out the implications of Masters's early, seemingly aborted life. In *The Palace of the Peacock*, the "I" narrator is Donne's brother, his shadowy alter ego. Like Harris himself, these narrators become the subjects of the stories they tell. In both novels the principal characters derive their energies from their associations with their opposites and antagonists. In-

dividual characters literally flow into the lives of their fellow inhabitants in these novels. Within this fluid fictive framework, there is no attempt at consolidation of character in these novels: the characters' self-constitutions and egos keep dissolving before our eyes.

Carnival is the story of the life and death of Everyman Masters, the name itself an allegorical trope that binds the colonizer and colonized in the same life, in the same time and space and historical fortune. Everyman Masters is a colonial subject reared and educated in the South American and Caribbean state of New Forest, where he rises to the status of plantation overseer. Everyman is paradoxically, then, an oppressor. He is "Masters," after all. But in this role Everyman Masters has to submit himself to what Harris calls "the therapy of justice." He pays with his life for his oppression of the plantation women who help to make up his labor force. Masters experiences what the narrator calls "his first death" when the wife of a fisherman, Jane Fisher the First, invites him to her home, on the understanding that her husband is away fishing, and stabs Masters to death.

But as always with Harris, the act itself is not an act of definitiveness or finality; it merely opens a doorway for the shadow of irony to cast its suspicions on both Masters and Jane the First herself. Jane the First mistakes Masters for a past lover who deceived her. Masters therefore enters a purgatorial cycle in which he must shoulder the guilt of the "sovereign demon" who "borrowed his face" (p. 156) to deceive Jane the First. Thus Masters is allowed a second life, this time in the imperial center in England. In his second life, Masters becomes an Everyman—one among the many West Indian and Asian immigrant minorities working in the factories of industrial England—a man, like characters Johnny the Plantation Czar and Carnival King of New Forest, carrying "a globe on his back." Masters is a postmodern Atlas, uprooted, deracinated, a hybrid of all dislocated subcultures—a folk hero with a partly malignant, partly redemptive history. When we first encounter Masters at the beginning of the novel, we meet him at the end of the second cycle of his life, mounting the stairs to his London apartment for a final rendezvous with Jane Fisher the Second. Masters is a latter-day Sweeney Erectus, driven by guilty desire to his untimely exit from this divine comedy of postcolonial life.

The second death takes place under shadowy circumstances. It is an apparent assassination by an intruder who enters through a door left ajar by the mercurial Jane Fisher the Second. But Masters's death is also a

final reconciliation with both Jane Fishers, and the reintegration of his psyche and tortured soul. In his dying moments, Masters finds expiation and release in the self-surrender of love: "A first and second death dying now as I embrace you my dearest enemy, my dearest love" (p. 14). Masters's final transformation has implications beyond its relevance to that of individual fate. His redemption has poignant meaning for the new relations in the post-plantation society. Harris (1983) describes this transformation as the psychic integration of self and other, a dramatization of the fissuring of those " 'object' or 'slave' functions consolidated in plantation psychologies' " (p. 120).

Masters, like most of the characters in *Carnival*, wears the twin masks of slave and overlord, plaintiff and accused, subject and object of history. There is also Johnny the Czar and Carnival King, a petty plantation bureaucrat by day and a village radical by night. There are, of course, Jane Fisher the First and Jane Fisher the Second, Amerindian wife of a fisherman of New Forest and the English paramour to Masters, respectively. There is Doubting Thomas, whose origins and parents the narrator cannot trace. He is the protector of the young Masters and heroic savior of Charlotte Bartleby, the market woman whom the racketeer Johnny the Czar attacks. Through these double characters, *Carnival* pursues its themes of transgression and reconciliation beyond life's stalemate of one-dimensional power. For Harris, the postcolonial relations to Empire can best be understood from the standpoint of a peculiar doubling of psyche, performance, and experience. The circulation of power and agency proceeds along a circuitous path, and no one, not even the oppressed can return to the state of innocence before the fall. As Everyman Masters puts it at the beginning of *Carnival*:

> Their [the oppressed] lives and deaths accumulate into statistics of motiveless or meaningless crime. How to identify those who are guilty, acquit those who are innocent! How to perceive the morality of *Carnival* within a universal plague of violence! That is our play. (p. 14)

Here, as Harris suggests, power relations run through the entire social body. And, to use the language of the postcolonial policy critic Uma Kothari (2001), these relations "are not confined to particular central sites nor located solely amongst the elite" (p. 20). In the role reversal and the exchange of hidden masks of colonial domination highlighted

in *Carnival* lay the groundwork for hope and possibility that reside in new structures of feeling, new terms of association and being unleashed in the carnival of history. Here in these acts of free association lies the possibility of what Harris (1983) calls "the comedy of freedom masking itself in claustrophobic ritual or vehicle" (p. xv).

Hybrid Subjects in *The Palace of the Peacock* and *Companions of the Day and Night*

In *The Palace of the Peacock* the counterpart to Everyman Masters is Donne, a Creole cattle rancher with a reputation for cruelty and hard-nosed efficiency. Even more directly than Masters, Donne represents the survival of a colonizing, adventurist, and instrumentalist spirit within the postcolonial setting. He is the colonizer in the colonized. When we encounter him, he too is dead, shot by Mariella, the colonized shaman woman whom Donne has abused. *The Palace of the Peacock* is set in the interior of Guyana. The story is that of a journey made in an open pontoon boat by Donne and a motley crew of racially ambiguous underlings. Their mission is to repossess an Amerindian settlement, or Maroon colony, established deep in the forest by runaway members of Donne's Amerindian workforce. This cross-cultural crew has a hard time of it. Because of the rugged nature of the terrain, many times they must disembark and haul their precarious boat overland through portages in the forest. At each point of their journey they are eluded by the Amerindian renegades. When they finally arrive at the Mission there is nobody there. They set off again, this time with an old Amerindian woman. On their second voyage out, the crew runs into a number of misfortunes. Some fall overboard. Others are killed in duels precipitated by the stress of the trip. Ultimately, the remainder of Donne's expeditionary party meet their deaths as they plunge over a waterfall to their perilous end.

These deaths are deeply symbolic. They represent a necessary dissolution of ego—the frustration and subversion of crass materialism. Death in Harris's novels often demarcates a transition—a doorway to a new experience of life, and a necessary condition for psychic and social reintegration and regeneration. After one of the many deaths on board, the crew members discover their deeper association beyond the petty differences that had divided them all along. The reality of shared experience, shared history, and shared identity is revealed in a vision that the I-narra-

tor experiences as Donne's crew approaches and finally enters the palace of the peacock—the mythical place of redemption and transformation at the top of a waterfall:

> The wall that had divided him from his true otherness and possession was a web of dreams. His feet climbed a little and they danced again, and the music of the peacock turned him into a subtle step and waltz like the grace and outspread fan of desire that had once been turned by the captain of the crew into a compulsive design and blind engine of war. His feet marched again as a spider's towards eternity, and the music he followed welled and circumnavigated the globe.... This was the inner music of the peacock I suddenly encountered and echoed and sang as I had never heard myself sing before. I felt the faces before me begin to fade and part company from me and from themselves as if our need of one another was now fulfilled, and our distance from each other was the distance of a sacrament, the sacrament and embrace we knew in one muse and one undying soul. Each of us now held at last in his arms what he had been forever seeking and what he had eternally possessed. (pp. 114–117)

This "discovery" of vital links and connections between the self and other in *The Palace of the Peacock*, and in *Carnival*, reminds us of a similar reintegrative motif that Harris pursues in another of his novels, *Companions of the Day and Night* (1975). On a sojourn to Mexico City, which lasts for centuries, *Companions*' apparently European/Everyman narrator, Idiot Nameless, finds himself inexplicably falling through passageways of historical ruins to the pre-Columbian past of Aztec and Toltec cultures. Harris links Idiot Nameless's "falling sickness" to the Aztec fear of the sun's irretrievable fall into darkness. Again and again in his wandering through postrevolutionary Mexico, Idiot Nameless enters, like a new millennial archeologist, into fields of unsettling contrasts and unexpected associations. In his tourist-like travels through the city, for example, Nameless encounters hidden Catholic convents buried alongside sunken pre-conquest Toltec shrines. What was obviously a Spanish colonial effort to deploy Catholicism against the native religion is recorded in a fossilized inventory that exposes the limits of colonial power, while affirming the rich cultural hybridity that is contemporary Mexico. The juxtaposition of these two erstwhile hostile cultures exemplifies Harris's insistence on cross-cultural interrogation and dialogue, his insistence on the radical interpretations of all cultures, and the growing interdependence of contemporary peoples.

Harris experiments in all of these novels with a radical subversion of the structure and deployment of characterization in the 19th-century novel. The characters that inhabit these postcolonial texts are peculiarly fragile: they flow into each other, they decompose and crumble like ancient masks recovered from an archeological digging. They are parodies of any certifiable identity. Their claim to truth, to objectivity, is ridiculed and imperiled. Like *Companions of the Day and Night*, *Carnival* and *The Palace of the Peacock* foreground a decentered, hybrid subject, alienated from any sense of predictable origins, constantly reassembling, like a bricoleur, the discontinuous elements of subordinate history.

THE RENDEZVOUS WITH PEDAGOGY

To return to our earlier questions: What do Harris's novels offer us as educators facing an increasingly delimited and circumscribed field of activity and influence? What might his insights provoke in the curriculum field in these times of crass localism, ethnic chauvinism, and its converse, multicultural appeasement? We see Harris's novels as an extended series of parables on the fate of the intellectual, of the educator—a kind of tragicomedy of the perils of fundamentalism and its corporate logics. The lesson is an apt one. As educators we tremble as the critical space in the field continues to collapse and a normative regime of truth inhabits not only our schools but academic life itself. The great struggle of our times is the struggle to regenerate a public sphere while the spheres of culture and education are increasingly colonized. Such a struggle necessitates giving up something, giving up our certainties and our illusions of control over knowledge. It means a powerful and painful kind of rapprochement.

Thus we may learn from the way Harris, in *Carnival* and *The Palace of the Peacock*, maps out the field of encounter of opposites in a disoriented world in which the paths to change reopen the old wounds of our colonizing histories, those unspeakable moments that Toni Morrison regards as the shared secrets of repressed memory and desire. The classroom has over time become the burial ground of genuine conversation and engagement—the place of perpetual avoidance of the combustible world outside. This avoidance is the Old World dispensation that inflects recent discourses in the educational arena of localism, centricities, panethnicities, practice versus theory, and so forth. We are lost in the world of ourselves, our group, our neighborhood, writing the world from our

suburban home—Sweeney Erectus's last stand. Perhaps no one has put it
more bluntly than bell hooks (1994) in her book *Teaching to Transgress*:

> In the weeks before the English Department at Oberlin College was
> about to decide whether or not I would be granted tenure, I was
> haunted by dreams of running away—of disappearing—yes, even of dy-
> ing. These dreams were not a response to the fear that I would not be
> granted tenure. They were a response to the reality that I *would* be
> granted tenure. I was afraid that I *would* be trapped in the academy for-
> ever. (p. 1)

But ultimately, in *Teaching to Transgress*, hooks plows her way out
of this fog and discovers the act of teaching to transgress, teaching as a
performative act in which "each class is different from the other." Find-
ing and sustaining these ex-centric, marginal spaces in education is the
great challenge of teaching in our time. In the world of Harris, it means
a willing death of authority over knowledge production, the quiet em-
brace of the fluidity of persons and identities that now people our class-
rooms and the world, and the pursuit of the loose ends of connectedness
and association across disparate fields of inquiry, humanity, and feeling,
wherever they may lead. This is our early-century challenge, carnival, and
play. It is also our great responsibility. As we enter the carnival, as we
give up our certainties, our prescribed and circumscribed roles, we must
be prepared to answer to our social others for our effects, intentional
and otherwise.
 We return, then, in the manner of Harris's "infinite rehearsal," back
to the concerns raised at the beginning of this chapter by Apple and
Schmidt, about the loss of the soul of teaching. These concerns are also
raised by school critics such as Thomas Popkewitz in his *Struggling for
the Soul* (1998) and John Devine in his *Maximum Security* (1996). The
daily grind of schooling has led us down a corridor of serial disinvest-
ments. According to these writers, we have handed over our bodies and
the bodies of our students to an impersonal educational regime of disci-
plinary surveillance, security systems, time on task, standardized testing,
and curricular formulas of knowledge insulation and ability grouping. By
performing the carnivalesque play in his novels, Harris challenges us with
the task of an existential problematization of our daily lives as educators.
Transformation in schooling must involve a pedagogy that reintroduces
all those endangered and discarded philosophies and pragmatics of living

with each other, within the context of material and cultural constraint and possibility.

The great challenge in the postcolonial environments in which we live is to rebuild the human community after the trauma of colonial administration and imposition. The great task set before teachers and educational practitioners today is the challenge of constructing a pragmatic process of meaningful, reciprocal communication that would help us reconnect our emotional and ethical investments with our work, our students, and each other. Borrowing from Harris, we argue that the quest for change in education must be linked to a deepening investment in community—a sense of community that must be built from the charred remains of modernization and colonization. We will build this community by re-infusing difference, plurality, heterogeneity, and intellectual problematization into the daily lives of our school children and into our lives as brokers of cultural knowledge and social change. In this way, we as educators "can become," in the language of William F. Pinar, "witness to the notion that intelligence and learning can lead to other worlds, not just the successful exploitation of this one" (Pinar, 2000, p. 10).

Toni Morrison's Pedagogical Vision

History and the Ethical Dimensions
of the Performative

As we argued in the previous chapter, postcolonial literature provides educators underutilized sites through which to interrogate questions of identity, community, and knowledge production in a world that has profoundly delimited and circumscribed the work they do. In this chapter, we would like to place the concerns of Caribbean writer Wilson Harris into dialogue with the concerns of American writer Toni Morrison. We thus return to the definition of the "postcolonial" outlined in the Introduction, namely that the postcolonial looks beyond spatial and temporal markers to broader kinds of dialogue between dispossessed and disenfranchised subjects, dialogue that foregrounds the partiality and contingency that is a central inheritance of modernism and colonialism.

Indeed, as indicated throughout this text, practices of colonial domination have been extreme and exorbitant, but never monolithic or complete. Language, history, and culture have all been sites of struggle between colonizers and colonized, between oppressors and oppressed. A sense of coherent origin and cultural unity has been shattered, though radically hybrid identities have proliferated in its wake. As Iain Chambers (1996) writes, in the postcolonial moment,

> The proprietary rights of language, history and truth are no longer able to hide in the metaphysical mimicry of universal knowledge or national identity. Such claims are now exposed through a radical historicity as partial, and partisan—accounts whose destiny is never to add up, to arrive at complete comprehension or an exhaustive account. They will always remain incomplete, mutable, historical, open. (p. 50)

Postcolonial writers and critics do not have an easy relationship with the past. The past is a record either of omission or of atrocity. Any sense of

history is necessarily partial and open, occupying an ambivalent space, a third or "in-between" space, to echo Bhabha.

We suggest that Morrison's work offers a quintessentially postcolonial vision of history—as partial, contingent, and open, though deeply rooted in political struggle and oppression. Her approach to the past places her concerns very much in dialogue with writers from the Third World and the periphery of the first such as Alejo Carpentier, Wilson Harris, and Edouard Glissant, for whom history is also a deeply political and necessarily partial struggle. These writers—Carpentier from Cuba, Harris from Guyana, and Glissant from Martinique—have had to transact complicated colonial pasts of Spanish, English and Dutch, and French domination in their work. This, along with their complicated and incestuous genealogies of indigenous Amerindian, African, and European family ancestries, makes for a profoundly heterogeneous sense of identity and affiliation. Heterogeneity and hybridity deeply inform their art and their social vision.

Barbara Webb (1992), in her book *Myth and History in Caribbean Fiction*, looks at these writers' complex cultural inheritances, arguing that

> Each of these writers recreates a history that has been perceived as absence or catastrophe in order to give it new meaning. Their aim is to transform the void of historical rupture and fragmentation into an open-ended vision of possibility. In this sense, their novels, like myth, are memories of the future. (p. 149)

In the work of Morrison, we see similar efforts to use the past as a resource for new and unpredictable futures. Morrison's historical vision is realized most fully in her self-described trilogy of books—*Beloved* (1987), *Jazz* (1992), and *Paradise* (1998). As we will discuss in more detail, *Beloved* takes as its subject African slavery; *Jazz*, the black migration from the South to the North; and *Paradise*, questions of black autonomy and community. Each of the books transforms bits and pieces of historical information unearthed by Morrison, mobilizing them to offer more complex notions of tradition, identity, and community. In particular, Morrison gives us new ways to think about the ethics of "performing" history, or making it continually relevant and politically efficacious for ever-changing audiences. Like Harris, Morrison offers a rich set of resources to educators.

EDUCATION, HISTORY, AND REPRESENTATION

Many critics have pointed out that one of the primary functions of "school" is to reproduce a sense of common culture, rooted in a shared notion of history (Apple, 1993; Cornbleth & Waugh, 1995). Schools have tended to produce overarching narratives about the nation-state complete with heroes, villains, and other prime movers, stories that make sense from dominant perspectives. One sees this plainly in textbook representations of slavery.

These representations, we find, tend to foreground either the economic necessity for slavery or the efforts of American citizens to repeal slavery through the Civil War. Though not named as such, slavery is placed into overarching stories of "progress." For example, the revised 1989 Amsco textbook *U.S. History Review Text* notes that "In 1619 the first black Africans arrived as prisoners aboard a Dutch ship and were purchased by the settlers as indentured servants. Later, to meet the ever-growing need for labor on the expanding tobacco plantations, other Africans were brought over and sold to the colonists as slaves" (Roberts, 1989, p. 30). Similarly, the revised 1993 Amsco textbook *American History: Review Text* notes that "Planters and farmers had difficulty in securing enough workers. Settlers were unwilling to work for others when they could easily acquire land and become independent farmers themselves. To overcome the labor shortage, colonists turned to Negro slaves and indentured servants" (Gordon, 1993, p. 22). The textbooks favor a history of economic progress, exonerating the horrors of slavery in favor of a propulsive narrative of success.

Of course, in recent years, these narratives have been expanded, within the United States and around the globe, to encompass the experiences of the dispossessed. Movements for more "inclusive" education have found their way into learning sites and curricula. However, as critics of multiculturalism have made so clear, these tend to be "add-on" approaches that append these experiences as a footnote to a larger grand narrative (McCarthy & Crichlow, 1993). More "multicultural" approaches, especially multicultural readers, have made efforts to open up this kind of history, often drawing together historical summaries with selections of literature and poetry. Two key examples are the collections *American Mosaic: Multicultural Readings in Context* (Rico & Mano, 1991) from Houghton Mifflin Company and *Negotiating Difference: Cultural Case Studies for Composition* (Bizzell & Herzberg, 1996) from St. Martin's Press. In both these cases, the editors attempt, quite laud-

ably, to offer a more sensitive political context for the lives of minority groups in the United States, hoping to offer a more complex picture of American history. Both reflect, however, some of the problems of doing so.

In the first case, the editors introduce the stories of "early immigrants," "Chinese immigrants," "African Americans," "Puerto Ricans," "Japanese Americans," "Chicanos," and "Native Americans," with brief historical sketches followed, typically, by some piece of legislation, and then literature and poetry. The section "African Americans: The Migration North and the Harlem Renaissance," for example, begins with some history about slavery, Reconstruction, and the Harlem Renaissance. The constitution of South Carolina is then followed by Alain Locke's introduction to *The New Negro*, which was written in 1925, a selection of writing by Zora Neale Hurston, and a poem by Langston Hughes (Rico & Mano, 1991, p. vi). This approach is mirrored for different ethnic groups, the goal being a fuller treatment "in context" of some of these authors and their works, in hopes of broadening American history to more closely resemble a "mosaic."

The second book takes a somewhat different approach. Here, the editors attempt to collect different articles, pieces of legislation, speeches, and so forth that speak to each other over debates around "difference," including "First Contacts between Puritans and Native Americans" and "The Debate over Slavery and the Declaration of Independence." Each section begins, again, with a historical sketch that typically narrates efforts of people in the United States to come to terms with class and cultural differences. The selections that follow show how invested agents "negotiated" questions of difference; for example, "Jefferson's Views on Slavery" is followed by "The Antislavery Battle," which is followed by "The Proslavery Defense" (Bizzell & Herzberg, 1996, pp. xv–xvi).

Both of these more progressive readers offer broader narratives than do conservative textbooks. However, the process of narrating history from a normative position is not vigorously called into question, nor is the easy delineation of culture challenged.

At their most reductive, multicultural approaches to education put the experiences of different groups—neatly divided—at the fingertips of students to consume. Ruth Vinz gives a most compelling (if hypothetical) example of what kinds of pedagogies this practice can foster:

On Monday of a given week, students begin their unit on Native Americans. They learn that Native Americans lived in teepees, used toma-

hawks to scalp white folks, wore headdresses, and danced together around a fire before eating their meal of blue corn and buffalo meat. By Wednesday of the same week, literature is added as an important cultural artifact; therefore, one or two poems (sometimes including Longfellow's "Hiawatha") represent tribal life of the past and present. By Friday, students take a trip to The Museum of the American Indian with its unsurpassed collection of artifacts and carry home their own renditions of teepees, tomahawks, or headdresses that they made during their art period. (Vinz, 1999, pp. 398–399)

As evidenced by Vinz's cautionary tale, the effect here can be an elision of the problems and tensions that inhere in the colonial encounter, a leveling out of difference in favor of overarching, superficial narratives.

We find, however, more satisfying and interesting treatments of these questions in art. Harris, Walcott, Allende, and others have wrestled with how to represent a past that is a record of domination and violence, of extreme and exorbitant physical and mental oppression. Derek Walcott's essay "The Muse of History" (1995) argues that history has been, to echo James Joyce, a nightmare from which colonial subjects have not yet awoken. The past, history itself, is overwhelming, necessitating the imaginative role of "myth" in forging new associations between disenfranchised subjects.

Walcott argues that it is impossible to preserve the past whole cloth. The past cannot be understood with any kind of narrative fullness:

In the New World servitude to the muse of history has produced a literature of recrimination and despair, a literature of revenge written by the descendents of slaves or a literature of remorse written by the descendents of masters. Because this literature serves historical truth, it yellows into polemic or evaporates in pathos. The truly tough aesthetic of the New World neither explains nor forgives history. It refuses to recognize it as a creative or culpable force. The shame and awe of history possesses poets of the Third World who think of language as enslavement and who, in a rage for identity, respect only incoherence or nostalgia. (p. 371)

The postcolonial artist, Walcott maintains, must not remain in "servitude" to history or "historical truth," as the suffering and pain of history cannot be contained within such narratives. He argues that we need new myths to draw together the past and the present in order to imagine different kinds of futures.

He himself created one such myth out of Homer's *Odyssey* in his powerful *Omeros* (1990). And, more recently, he has expanded this thesis of the yoking of contestatory histories in his remarkable long poem *Tiepolo's Hound* (2000). The poem stages the linked quests of impressionist painter Camille Pissaro, a Sephardic Jew, who leaves his Caribbean home of St. Thomas to travel to Paris in the 19th century to pursue his vocation, and the philosophical and sensory contemporary journey of the poet himself, who longs to rediscover a very specific detail in a Venetian painting that he encountered on one of his early visits from his island home in St. Lucia to New York. Other artists, including Toni Morrison, have committed themselves to similar efforts to creatively redeploy historical knowledge.

EXCAVATING A PEDAGOGY OF HISTORY
IN TONI MORRISON'S NOVELS

Morrison's work emerged during the early 1970s, in the wake of the black nationalist art movement. Artists and critics who emerged from this movement—Amiri Baraka and Ron Karenga, among others—brought a narrative finitude to "blackness" and linked it to a seemingly inevitable revolution of black people. For Karenga, who headed the cultural nationalist "U.S." movement and would later invent the holiday of Kwanzaa, art that was based on African "characteristics" would be central to the revolution. He writes, "For all art must reflect and support the Black Revolution, and any art that does not discuss and contribute to the revolution is invalid, no matter how many lines and spaces are produced in proportion and symmetry and no matter how many sounds are boxed in or blown out and called music" (Karenga, 1972, p. 478). Quite clearly, the black nationalist movement had a sense of the common vanguard, linked to a collective and assumed past, present, and future.

Morrison, however, does not place herself at the "vanguard" of a black revolution. While Karenga and others used their unitary notion of African blackness as the basis for a new and different future, Morrison holds a very different vision of history. She says, "I know I can't change the future but I can change the past. It is the past, not the future, which is infinite. Our past was appropriated. I am one of the people who has to reappropriate it" (quoted in Taylor-Guthrie, 1994, pp. xiii–xiv). From counter-memories of blackness rooted in this infinite past, in novels like

Beloved, *Jazz*, and *Paradise*, Morrison is able to generate mythologies that allow educators to reflect on different kinds of futures.

What we see in Morrison is a complex process of forgetting and remembering, which places tremendous responsibility in the hands of the author. For example, the novel *Beloved* tells the story of Sethe, who kills her child Beloved rather than see her returned to her "owner." Sethe and her other daughter, Denver, spend much of the novel haunted by Beloved's ghost. The characters in this book have to literally beat back the past. Sethe talks of an "unrepeatable" past, one she has always to keep "at bay." Because the story of the past is so volatile, individuals must take responsibility for the telling, for each particular iteration. Each telling re-performs history, and this places much onus on the teller.

Morrison's novels are records of such counter-memory, "remembrances" that challenge received notions of identity and tradition. History is a process by which people must come to terms with a past that will not go away, a past that cannot be pacified by narrative. History is a nonlinear struggle between irreconcilable stories. She writes, "To Sethe, the future was a matter of keeping the past at bay. The 'better life' she believed she and Denver were living was simply not that other one" (1987, p. 42). Histories exist side by side. There is no simple teleology that places the past in easy relation to the present and future. History cannot be resolved through narrative closure. Its pain can only be managed.

This approach to history is fundamentally different from the often (though not always) linear ones taken by Eurocentric conservatives, Afrocentrists, and multiculturalists. Each of these latter approaches, at their most reductive, offers a narrative of the past and present that reinforces stable notions of cultural origins. The past is present for these social combatants in full and originary form. For Morrison, however, the past entails new questions and responsibilities. Each of Morrison's novels takes on a piece of black history in the United States in a "trilogy" that blurs the line between personal stories and wider black narratives. As George Lipsitz (1990) suggests, such "[c]ounter-memory focuses on localized experiences with oppression, using them to reframe and refocus dominant narratives purporting to represent universal expedience" (p. 213).

Beloved is based on the story of Margaret Garner, a slave on the run who, in danger of being caught, tried to kill her three children. Morrison recalls having heard about this story but was directly influenced by a

newspaper clipping collected in a book that she herself edited while at Random House, *The Black Book*. She is, as always, worth quoting at length here:

> I had an idea that I didn't know was a book idea, but I do remember being obsessed by two or three little fragments of stories that I heard from different places. One was a newspaper clipping about a woman named Margaret Garner in 1851. It said that the Abolitionists made a great deal out of her case because she had escaped from Kentucky, I think, with her four children. She lived in a little neighborhood just out-side of Cincinnati and she had killed her children. She succeeded in killing one; she tried to kill two others. She hit them in the head with a shovel and they were wounded but they didn't die. And there was a smaller one that she had at her breast. The interesting thing, in addition to that, were the interviews she gave. She was a young woman. In the inked pictures of her she seemed a very quiet, very serene-looking woman and everyone who interviewed her remarked about her serenity and tranquility. She said "I will not let those children live how I have lived." She had run off into a little woodshed right outside her house to kill them because she had been caught as a fugitive. And she had made up her mind that they would not suffer the way she had and it was better for them to die. And her mother-in-law was in the house at the same time and she said, "I watched her and I neither encouraged her nor discouraged her." (quoted in Taylor-Guthrie, 1994, pp. 206–207)

Interestingly, Morrison connected this story to one she gleaned from another source. She goes on:

> But that moment, that decision was a piece, a tail of something that was always around, and it didn't get clear for me until I was thinking of another story that I had read in a book that Camille Billops published, a collection of pictures by Van der Zee, called *The Harlem Book of the Dead*. . . . In one picture, there was a young girl lying in a coffin and he says she was eighteen years old and had gone to a party and that she was dancing and suddenly she slumped and they noticed there was blood on her and they said "What happened to you?" And she said, "I'll tell you tomorrow. I'll tell you tomorrow." That's all she would say. And apparently her ex-boyfriend or somebody who was jealous had come into the party with a gun and a silencer and shot her. And she kept saying, "I'll tell you tomorrow" because she wanted him to get away. (quoted in Taylor-Guthrie, 1994, p. 207)

Though Morrison had originally seen these two stories as connected to one larger narrative, they eventually became two separate books. The first, again, was *Beloved*; the second was *Jazz*.

In *Jazz*, Morrison would tell a story about a murderous love triangle between Dorcas, a young woman, and Joe and Violet, a married couple, set against the backdrop of Harlem during the 1920s and the migration of rural blacks from the South to the North. The familiar tropes of jazz music, the railroad, and the liberating and constraining anonymity of urban living frame the complex affections and obsessions that drive the lives of Dorcas, Joe, and Violet and drive Joe to murder Dorcas and Violet to desecrate her corpse at her funeral. This surprisingly understated human drama unfolds as the so-called Harlem Renaissance rages.

Paradise is the third of this trilogy. This novel is based on stories about the westward migration of blacks following the abolition of slavery in the 19th century. Morrison recalls several newspaper advertisements that sparked her historical imagination here, advertisements proclaiming "Come Prepared or Not at All," calling newly freed slaves to head out West and explore this seemingly untrammeled land (Gray, 1998, p. 62). The freedom to forge some kind of autonomous community, Morrison shows, was girded by the violence of men and the exclusion of women. In fact, the book was originally titled *War*, though her editors suggested *Paradise*. Morrison traces several migrations of a single black community up until the 1970s, when anxieties about 1960s idealism and its attendant attitudes toward social and cultural mores prompt the town's men to exterminate a house full of women. The house, where most of the town's women have retreated, becomes a horrific site of difference for these patriarchs.

In all these cases Morrison has taken brute historical facts and compellingly transformed them into novel form. Mimesis or faithfulness is not as important as her own unique telling, her responsibility toward history. Like other postcolonial artists, she rejects the grand narratives of the past while offering myths resilient enough to help beleaguered communities survive in the face of colonial terror. Morrison and her postcolonial counterparts find the realist novel's claims to authority and completeness of knowledge, reason, and ethics insufferable.

While Morrison challenges *a priori* racial narratives, she also argues for the resiliency of notions of what it means to be black. Morrison offers us visions of blackness that are strong due not to an enduring essence,

as the black nationalists would have it, but to black people's ability to invent and reinvent themselves in the face of extreme oppression—indeed, genocide. Her vision of tradition is a protean one, open to multiple manifestations, nurturing of a community's vision and voice. Her struggle for a more humane social language offers us all a way to look beyond the narrowing of imagination about the past that is so entrenched in the social sciences and educational practice today. "The ideal situation is to take from the past and apply it to the future," Morrison writes, "which doesn't mean improving the past or tomorrow. It means selecting from it" (quoted in Taylor-Guthrie, 1994, p. 112).

Beloved and Slavery in the United States

Beloved exemplifies Morrison's treatment of history in the way that Sethe comes to terms with a horrific event in the past—the death of her child. Living in a cabin, secluded from the community, Sethe, her daughter, Denver, and her lover, Paul D., are haunted by the ghost of Beloved. The novel details Sethe's piecemeal remembrance of the "mercy" killing of her daughter, her increasing seclusion from the community, and the community's role in ultimately supporting her and her daughter. The truth is not revealed completely to her but must be brought into the present piece by piece. The pressures of Sethe's traumatic past are enormous. Morrison writes, "Her brain was not interested in the future. Loaded with the past and hungry for more, it left her no room to imagine, let alone plan for the next day" (1987, p. 70). In fact, the revelation about what happened to Beloved comes nearly halfway through the book.

The role of Beloved is ever unclear. She appears, causes havoc, disappears, and reappears at key moments. The trauma of remembrance is made real by Morrison. Indeed, Morrison's narrative breaks apart toward the end of the book as Beloved becomes ever more real for Sethe and Denver. Morrison evokes what seems like a dialogue with Beloved:

> Tell me the truth. Didn't you come from the other side?
> Yes, I was on the other side.
> You came back because of me?
> Yes.
> You rememory me?
> Yes, I remember you. (p. 215)

Beloved is nonlinear, in order to tell stories that are difficult to place into ready-made languages or package into narratives with a simple logic or sequential ordering of events. As Morrison reflects in an interview,

> I think what's important about it [*Beloved*] is the process by which we construct and deconstruct reality in order to be able to function in it. I'm trying to explore how a people—in this case one individual or a small group of individuals—absorbs and rejects information on a very personal level about something [slavery] that is indigestible and unabsorbable, completely. (quoted in Taylor-Guthrie, 1994, p. 235)

This process of performing history is an ethical process. If history is mobilized in particular ways by particular agents, then it cannot be morally neutral. Della Pollock makes this point quite powerfully in her collection *Exceptional Spaces* (1998). For Pollock, the idea that history can be transparently represented abdicates agents of ethical responsibility for how history is made real, compelling, and politically efficacious in the here and how. At its best, a "performance" of history invests the teller with a kind of moment-to-moment responsibility, the responsibility of storytelling.

Morrison draws on a complex moral universe that challenges the binary logics at the heart of Western imperialism and domination. Black communities, as Morrison has written, have a tremendous amount of resiliency in what they can collectively deal with, and they need not seek to eradicate "evil" in the ways that Europeans do. She writes, "It always interested me, the way in which black people responded to evil. They would protect themselves from it, they would avoid it, they might even be terrified of it, but it wasn't as though it were abnormal" (quoted in Taylor-Guthrie, 1994, p. 100). Morrison does not give us an easy moral stance toward history. The past, for Morrison, is not girded by easy ethical binaries and norms, clear distinctions for right versus wrong. The horrific past of imperialism and colonization has made such distinctions, at best, facile.

Morrison bore the brunt of criticism in *The New York Review of Books* when Diane Johnson wrote that her novels "entirely concern black people who violate, victimize, and kill each other." "Are blacks really like this?," Johnson asks, before concluding that Morrison's novels don't have "the complicating features of meaning or moral commitment" (quoted in Taylor-Guthrie, 1994, p. 57). Conservative black critic Stanley Crouch, in turn, argues that *Beloved* is valueless because it allows us

to exonerate Sethe's evil act (Crouch, 1990). These critics' easy divisions between good and bad are part of the larger project of ressentiment that seeks to purify a white world in relation to that which it is not and to provide a cleansed, "positive" image of black life. This distinction is not a relevant one for Morrison. This kind of purity has never been afforded postcolonial artists. We recall here Baldwin's (1976) comments on the film *The Exorcist*: For Baldwin, the most frightening thing about this film was the idea that evil could somehow be "exorcised" by good. White audiences, he implies, have the luxury of seeing evil as "other," as distant, as something that can be eliminated. This Manichean approach to good and evil belies the historical struggles of marginalized peoples.

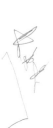

Jazz and the Urban Migration

In *Jazz*, too, history and ethics are inseparable. *Jazz*, recall, is the story of a couple, Violet and Joe, who make the fabled migration from the South to Harlem in the 1920s. This is the height of the so-called "Harlem Renaissance," though there is no mention of this; its commodification of black life for white people is clearly implied. The city is a highly impersonal though extremely exciting place, opening up new kinds of passions and desires for both. As Morrison writes, "People look forward to weekends for connections, revisions and separations even though many of these activities are accompanied by bruises and even a spot of blood, for excitement runs high on Friday or Saturday" (1992, p. 50). Soon after their arrival in Harlem, Joe begins an obsessive affair with a teenage girl named Dorcas. She evokes in him feelings he is incapable of dealing with, and he eventually kills her at a party. Joe, the narrator explains, is "scared" and "didn't know how to love anybody" (p. 213).

The community itself serves as a backdrop for Joe's act. There is no explicit judgment of Joe, nor of Violet, who stunningly cuts up Dorcas's corpse at her funeral. It is a horrifying set of incidents, but Morrison does not give us an easy narrative resolution. Neither is cast out of the community, nor are they handed over to the police for punishment. Morrison offers us the reflections of Dorcas's aunt, Alice:

> Alice Manfred had seen much and borne much, had been scared all over the country, in every street of it. Only now did she feel totally unsafe because the brutalizing men and their brutal women were not just out there, they were in her block, her house. A man had come into her

> living room and destroyed her niece. His wife had come right in the funeral to nasty and dishonor her. She would have called the police after both of them if everything she knew about Negro life had made it even possible to consider. To actually volunteer to talk to one, black or white, to let him in her house, watch him adjust his hips in her chair to accommodate the blue steel that make him a man. (p. 74)

Evil is not something to be destroyed but to be lived with. In a particularly powerful scene, Violet visits Dorcas's aunt, Alice, after Dorcas's funeral. Though Alice calls her "evil," the women sit down for tea.

> Alice handed her the tea. "I don't understand women like you. Women with knives." She snatched up a long-sleeved blouse and smoothed it over the ironing board.
> "I wasn't born with a knife."
> "No, but you picked one up."
> "You never did?" Violet blew ripples in the tea.
> "No I never did. Even when my husband ran off I never did that. And you. You didn't even have a worthy enemy. Somebody worth killing. You picked up a knife to insult a dead girl."
> "But that's better ain't it? The harm was already done."
> "She wasn't the enemy."
> "Oh, yes she is. She's my enemy. Then, when I didn't know it, and now too."
> "Why? Because she was young and pretty and took your husband away from you?"
> Violet sipped her tea and did not answer. After a long silence, and after their talk had turned to trifles then on to the narrowness of life, Violet said to Alice Manfred, "Wouldn't you? You wouldn't fight for your man?" (p. 85)

Morrison does not judge Joe, nor does she judge Violet. She neither exonerates nor condemns but suggests that struggles with evil are day-to-day and mundane in the context of a community that does not have the luxury of simply "exorcising" evil. Morrison gives the reader no comfortable way to relate to the past.

Paradise and Black Autonomy

Morrison brings these concerns about ethics and community full circle in her most recent novel, *Paradise*. The story opens in the town of Ruby

with a massacre at the "Convent," a house where several women in the all-black town have taken up residence. These killings are the final desperate act of a group of men looking to reclaim their patriarchal privilege. These men, the descendants of Ruby's founding fathers, desire to reinstate a highly masculine vision of community, one that strives for a kind of certainty based on blood and land. Like many separatist movements, this is one prompted by physical threat (here of whites) but results in internal subordination and exclusion as well (here, of the town's women). Morrison describes the original vision and this original migration:

> In 1890 they had been in the country for one hundred and twenty years. So they took that history, those years, each other and their uncorrectable worthiness and walked to the "Run." Walked from Mississippi and Louisiana to Oklahoma and got to the place described in advertisements carefully folded in their shoes or creased into the brims of their hats only to be shooed away. (1998, pp. 193–194)

Throughout the text, the descendants of the so-called "8-rock blood" try to maintain both their masculine and patriarchal power, protecting the town from racist whites while they marginalize the town's women. The patriarch's symbolic and arbitrary power is evidenced most sharply by the iron oven that sits in the middle of the town. This oven had been part of the original settlement, was dissembled for a second migration, and was reassembled piece by piece. Representing both the tenacity and the burden of historical identity, the oven becomes a site of intense anxiety and is eventually vandalized by some youths.

Indeed, this community is filled with strife and in the 1970s, in the face of more radical demands of the younger generation, these men do what white people did—they try to purify themselves through "exterminating evil." The novel opens with the unforgettable passage:

> They shoot the white girl first. With the rest they can take their time. No need to hurry out here. They are seventeen miles from a town which had ninety miles between it and any other. Hiding places will be plentiful in the Convent, but they have time and the day has just begun. (p. 3)

While the characters in *Beloved* and *Jazz* seem capable of living in a world of ethical ambiguity, where "good" and "bad" cannot be so easily distinguished, the black men of *Paradise* draw on the same Manichean world-

view that undergirds colonization itself. They seek to control and elimi-nate difference, to purify themselves through the annihilation of the "other," in an extreme manifestation of ressentiment (McCarthy & Di-mitriadis, 2000).

CONCLUSION: MORRISON, EDUCATION, AND
THE ROLE OF THE PUBLIC INTELLECTUAL

Throughout her collected works, Morrison struggles against the vision of community based on exclusion. She both condemns the restrictive model and speaks to new, open kinds of association in *Paradise* as throughout her other novels, such as *The Bluest Eye* (1972), *Sula* (1974), *Tar Baby* (1981), *Song of Solomon* (1977), *Beloved*, and *Jazz*. For Mor-rison, the novel and the novelist can play a role in reconstituting the generational lines and ties she sees as broken among young African Americans today. Schools have traditionally been concerned with trans-mitting historical knowledge across generations, but this tends to be a linear and restrictive history. Morrison makes clear that such approaches have never been relevant for African Americans, whose more relevant education takes place outside school. She notes that "there were two sorts of education that were going on—a school education, and another education, and the one that stuck was the one not in the school" (quoted in Taylor-Guthrie, 1994, p. 172). The relevant education, education about survival itself, took place in churches, street corners, and in other locally validated settings. It was essential to sustaining the kinds of com-munities she writes about throughout her oeuvre.

However, these kinds of institutions have been lost, Morrison ar-gues, along with shared notions of identity. "It's like you used to be born Black, and that meant something. It meant that when you saw another Black person you knew all sort of things right away . . . There were some things you could count on, some language, some shared as-sumptions. That doesn't seem to be true now" (p. 186). The things that used to hold African American communities together are no longer there. Her novels are about the reintegration and the reconstitution of this community of lost souls. Echoing the concerns of Harris, she notes:

> Myth is the first information there is, and it says realms more than what
> is usually there . . . It takes some effort to keep a family together, a

neighborhood together. So since that is the case, the old stories don't work any more and songs don't work any more, that folk art that kept us alive. So now I think novels are important because they're socially responsible. . . . I don't mean just reading a good story either. I mean a novel written a certain way can do precisely what spirituals used to do. It can do exactly what blues or jazz or gossip or stories or myths or folklore did. (quoted in Taylor-Guthrie, 1994, p. 183)

Writing novels, for Morrison, is akin to spinning "village lore," to constructing life—and community-sustaining myths.

Morrison thus offers us new ways to think about community, ethics, and the responsibilities we all have to perform history, to make it relevant in the present tense. Indeed, Morrison transforms the old models, which ask teachers and students to come to terms with a fixed body of historical fact, into a view of history as partial, and part of a collective project in which we are all invested. In doing so, Morrison opens up new roles for educators to help reconstitute communities and collectives by imagining history as a shared and unpredictable work in progress. Taking Morrison seriously means attending to the radical particularity of the history classroom and how teachers and young people conjure up a past for which they must take mutual responsibility.

Three Postcolonial Painters

The Pedagogies of Bennett,
Roche-Rabell, and Basquiat

We have argued throughout this book that the boundaries between different art forms are illusions maintained by institutional imperatives and belied by the work of artists in practice. In this chapter, we turn our gaze to the visual art and the work of three postcolonial artists who are dispersed geographically and culturally, but united in their approaches to the colonial inheritance they have all been bequeathed. In turning to visual art, we challenge the dominance of literature in the academy today, realized in the unfortunate conflation of postcolonial theory and literary criticism. In this chapter and the next, we turn to nonnarrative and nonverbal ways of knowing, in an attempt to broaden debates around postcolonial and multicultural theory and to bring a larger set of resources to educators wrestling with questions about identity and culture.

We focus, specifically, on the work of Gordon Bennett, a Euro-Aboriginal painter from Australia; Arnaldo Roche-Rabell, an Afro-Latin painter from Puerto Rico; and finally Haitian-Puerto Rican—American artist Jean-Michel Basquiat. All three artists mine the energy and complexity of identity formation for marginalized subjects in the Third World and on the periphery of the first. All three draw on the specific experiences, traditions, and histories of marginalized and oppressed groups. Yet they resist the temptation to posit linear, unitary, or homogenous notions of culture in opposition to the dominant colonial system. All three refuse to invest the dichotomy between colonizer and colonized with any kind of stability or immutability. These artists are not "folk artists." They make more fundamental kinds of demands that extend beyond questions of validation or inclusion.

The work of these artists offers resources for educators struggling with how to address questions of identity and culture in classrooms, challenging the ready-made efforts of so many multiculturalists. As we noted

in the last chapter, multicultural educators typically cordon off different groups by way of cultural origin, often arguing for a kind of easy "dialogue" between them. This is part of a larger project of ressentiment that seeks to pacify the extraordinary tensions and difficulties that accompany cultural exchanges across the globe today—a point we will pick up in the conclusion to this book. There are no authentic origins, however, for Bennett, Roche-Rabell, or Basquiat. The inheritance of cultural resources is there for them to use, not necessarily to respect. "High" and "low" dwell side by side. All deploy a whole panoply of cultural signs, symbols, and histories in order to construct and reconstruct identities.

These artists' notions of tradition and culture exceed particularism. Instead, they connect their deep-bodied understandings of tradition and culture to the task of decoding the social and political complexities of our moment. Take, for instance, the modern inheritance of Vincent van Gogh. In many respects, van Gogh lived out the quintessential narrative of Western high art. He became a leading proponent of "expressionism," lead a tortured, isolated life, and was only appreciated after he died. His isolation from others, his internal life, and his mental illness were very much a part of his myth, as much as his work itself. Bennett, Roche-Rabell, and Basquiat all work in the symbolic universe bequeathed by van Gogh, though they offer key counter-examples, stressing that the self is always to be found in community.

Both Bennett and Roche-Rabell, in particular, have explicitly reworked some of van Gogh's most famous images. Bennett's *The Outsider* ironically and densely reworks *Starry Night* and *Vincent's Bedroom in Arles* in a critique of Bennett's own European inheritance, beginning with classical Greece. *The Outsider* (Figure 5.1) recodes the personal emotional violence of van Gogh's paintings as social violence, depicting a decapitated native body stumbling toward a blood-besmirched cradle on which lie two classical Greek heads. Double vision packs the ground of essential Aboriginal and hegemonic Anglo-Australian identities with trip wire questions, making visible the symbolic violence of Australian history and the brutality of European "discovery" and domination of the native. In addition, van Gogh's well-known images of sunflowers became fodder for Roche-Rabell's *Five Hundred Years without an Ear* (Figure 5.2). Here, Roche-Rabell inters an agonized-looking figure in a field of menacing sunflowers, a metaphor for both his debt to the European tradition and its profound pains.

Figure 5.1. *The Outsider* by Gordon Bennett.

Figure 5.2. *Five Hundred Years without an Ear* by Arnaldo Roche-Rabell.

It would be a mistake, however, to call these motifs "influences" pure and simple. Such language tends to serve systematic and linear— and specifically nationalistic—kinds of histories. In contrast, Bennett and Roche-Rabell achieve a radical juxtaposition of cultural signs and symbols in order to challenge the Eurocentric illusion of whiteness as a category above and outside of time and history.

All three painters, then, acknowledge the inextricably hybrid nature of all cultural experience. Hybridity, of course, has become a popular way to think about identity in the contemporary era of globalization. Yet the concept can invite a narrow kind of reading, one that assumes a kind of cultural borrowing and mixing between cultural groups and entities that remain discreet (Tomlinson, 1999). In many ways, theorists of hybridity merely reinscribe the notion of cultural origin discussed above. Yet hybridity can also signify a radical reconception of *all* received culture. Renato Rosaldo writes:

On the one hand, hybridity can imply a space betwixt and between two zones of purity in a manner that follows biological usage that distin-

guishes two discrete species and the hybrid pseudo-species that results from their combination. Similarly, the anthropological concept of syncretism asserts, for example, that folk Catholicism occupies a hybrid site midway between the purity of Catholicism and that of indigenous religion. On the other hand, hybridity can be understood as the ongoing condition of all human cultures, which contains no zones of purity because they undergo continuous processes of transculturation (two-way borrowing and lending between cultures). Instead of hybridity versus purity, this view suggests that it is hybridity all the way down. (quoted in Tomlinson, 1999, p. 143)

All three of the painters discussed below draw on and acknowledge hybridity in this latter sense and link it to broader political questions.

Bennett's work, for example, is concerned primarily with the unstable role of aboriginal Australians in the modern world. Roche-Rabell, in turn, draws on themes central to the plight of Puerto Rico and its fate as a "commonwealth" of the United States. Finally, Basquiat's work is concerned primarily with the radical instability of identity in the American metropolis, the ways lived identities exceed the stable categories we have developed to understand them.

Juxtaposing Bennett, Roche-Rabell, and Basquiat allows us to interrogate colonial processes in all of their particularity—questions of "here" versus "there" as they play out in multiple sites in different ways. Each of these colonial experiences is different. Australia was declared "terra nullius," or empty land, by Great Britain when it established a penal colony there in 1788—thus conveniently, and brutally, eliding the 40,000-year history of Aborigines who occupied the land. Puerto Rico has the dubious distinction of being considered a "voluntary commonwealth" of the United States. The situation is fraught with uncertainty: some Puerto Ricans call for independence, some for statehood within the United States, and others for the status quo. Finally, black people in the United States experience a unique kind of colonization. Slaves by lawful regulation up until almost the end of the third quarter of the nineteenth century, blacks have faced a unique set of social, political, and legal constraints leading to a particular kind of colonization that is, in equal measure, cultural and material. "Freedom" and "democracy" do not translate easily across the black–white divide in the United States. Thus these artists all engage with historically unique social and political situations, where the future is both open and fraught with uncertainty.

While each of these political situations is unique, they share certain commonalities. The experience of colonial domination has registered on

myriad levels, making received history a site of ambivalence and tradition something that is always in process. These artists share Toni Morrison's project, discussed in the last chapter, to use the past as a resource to construct different kinds of futures. These paintings evidence a common struggle to come to terms with self through history and community, and the use of myriad tools—some of which "belong" to the colonizer. They show evidence of profound personal struggles that transcend the limits of ancestry, language, and geography while being bound to the particularity of situation.

GORDON BENNETT

Bob Lingard and Fazal Rizvi write that "In Australia, colonialism has operated in two ways: internally in relation to Aboriginal people and externally in relation to Europe" (1994, p. 75). This sums up some of the tensions Australia faces as it attempts to throw off the shackles of its colonial past and define a new postcolonial future. With recent, "tentative moves" toward republic-hood coming alongside the Mabo High Court decision, which legitimizes the land rights of Aborigines, this is an uncertain space.

Through his art Gordon Bennett, the son of an Aboriginal mother and European father, comes to terms with the profound personal and political issues that inform Australian postcolonial identity. Bennett came to art relatively late in life, graduating from art school in 1988 at the age of 33, the year Australia celebrated the bicentennial of European settlement. His work registers the attendant tensions and concerns here. Indeed, Bennett draws on a quintessential postcolonial ambivalence toward identity in registering multiple futures for Australia. Most importantly, we see his efforts to come to some terms with his own complex cultural inheritance, connected to a sense of a broader Aboriginal-Australian community. His personal struggle is thus constitutively linked to the future of Australia as a postcolonial nation. His "becoming" is, in some sense, Australia's "becoming."

Gordon Bennett was not aware until he was 11 that he had some sort of Aboriginal heritage. The fact, quite simply, did not register with him, though his mother was Aboriginal. His father, however, was European, held some racist views, and was a member of the military. He grew up in an overwhelmingly Euro-Australian environment, one reinforced both at home and in school. As he has repeatedly stressed, the only

things he learned about Aborigines were in the school curriculum, which reaffirmed a colonial history. These histories ranged from the explicitly racist to the seemingly measured. Each, however, worked to elide Aborigines from contemporary debates, and was undergirded by Enlightenment narratives that valued colonialism as a form of progress.

Bennett's own frustration and alienation with official Australian history is underscored by a 1917 school textbook, which he quotes: "When people talk about 'the history of Australia' they mean the history of white people who have lived in Australia." He recalls that this schoolbook elevated "men of science" who could "tell us how these white folk found the land, how they settled in it, how they explored it, and how they gradually made it into the Australia we know today" (quoted in McLean & Bennett, 1996, pp. 20–21). Bennett's first school experiences reinforced a brutal white supremacist vision that erased Aborigines from history.

Bennett notes that "very little" changed during the 1960s (when he attended primary school). However, if the textbook quoted above was explicitly racist, he notes that another kind of racism fed into the curriculum at this later date. Now we see Aborigines treated as an anthropological curiosity. He recalls:

> In the two-room school in Diggers Rest I learnt that Aborigines had dark brown skin, thin limbs, thick lips, black hair and dark brown eyes. I did drawings of tools and weapons in my project book, just like all the other children, and like them I also wrote in my books that each Aboriginal family had their own hut, that men hunt kangaroos, possums, and emus; that women collect seeds, eggs, fruit and yams. The men also paint their bodies in red, yellow, white and black, or in feather down stuck with human blood when they dress up, and make music with a didgeridoo. That was to be the extent of my formal education on Aborigines and Aboriginal culture until Art college. (quoted in McLean & Bennett, 1996, p. 21)

This is a classic anthropological approach that aims to essentialize and homogenize what it means to be Aboriginal. The search for anthropological purity tends to ignore the everyday struggle around identity that is the norm for urban Aborigines. For young Gordon, being Aboriginal was clearly an anomaly. It meant being a living, breathing anachronism—out of step, out of place, and out of contemporary time. His

experience reinforces the failings of multicultural pedagogy referenced by Ruth Vinz in the last chapter, where individual groups, neatly delineated, neatly separated, are presented as fully knowable. Such pedagogy abdicates responsibility, as Pollock (1998) notes, for making these histories present and real.

Bennett's canvases offer an explicit counter-pedagogy to his school learning. On one level, Bennett simply offers a more inclusive kind of representation as he attempts to insert a broader range of faces into the canon. However, Bennett's critique is deeper, interrogating as he does the Enlightenment ideals realized in traditional curricula that naturalize a tidy and linear history. He demands more than mere inclusion or "voice." This critique is at work in *The Outsider*, discussed earlier, as well as in paintings such as *The Coming of the Light* (1987). The "coming of the light," or the Enlightenment, is represented by a disembodied arm with hands at either end. One clutches a torch, the symbol of Enlightenment ideals, which illuminates a backdrop of skyscrapers—the fulfillment of modernization and progress in the Australian city. The other clutches a belt wrapped around the head of an Aboriginal man about to be lowered into an open box on which the letter "A" ("A" for Aboriginal? "A" for assimilated? "A" for accused?) is painted. The message is clear—Enlightenment ideals of education are deathly to the Aboriginal. The project of modernization has claimed a victim through its processes of routinization and labeling.

But this man, however, is one in a long line of faces. These other faces peer out from behind a conveyor belt of boxes, each box, as previously mentioned, labeled with a letter of the alphabet, "B," "C," "D," and so on. These faces are white faces filled with wonder, awe, and fear. And it appears that they await a similar fate as that endured by the Aboriginal figure. They will be boxed into this routinized system that colonial education functions to reproduce. Bennett thus suggests that all these people share a common fate as they face a colonizing educational system.

Educators have traditionally claimed authority over knowledge, allowing them to defended curricula as transcendently "true." Young people are, of course, seldom taught that there are multiple truths, that "reason" and "logic" are situated in particular times and places, for particular people with particular interests. In her critique of current educational reforms, Catherine Cornbleth (1990) writes of "logic," that preeminent Enlightenment ideal, "While students may learn now to con-

struct a 'logical' argument, they do not learn that different logics have
been created in different times and places to serve different purposes" (p.
11). Enlightenment ideas are thus naturalized by the curriculum, made
"common sense." We recall the comment earlier about "men of science"
and their role in justifying white dominance in Australia. Bennett decon-
structs these Enlightenment ideals throughout his work, opening them
up to sustained critique.

In paintings such as *Terra Nullius* (1989), *The Nine Ricochets (Fall
Down Black Fella, Jump Up White Fella)* (1990), and *Prologue: They
Sailed Slowly Nearer* (1988), Bennett explicitly critiques British colonial
processes that sought to erase Aborigines from the continent, while also
linking this kind of domination to Enlightenment rationality. *Prologue:
They Sailed Slowly Nearer* presents this relationship as a dialectic. The left
side of the painting features forms emerging from a vanishing point that
look like wooden planks, while the right features images of British "ex-
plorers" approaching Aborigines. Enlightenment rationality, visualized
in the triumph of optical perspective, is juxtaposed and found lacking
next to the experiential space of "primitive" Aborigines. Bennett often
explicitly critiques Renaissance optical perspective, and its implied inabil-
ity to imagine other ways of being, in paintings that caricature perspec-
tive by labeling it "CVP," or Central View Point, and superimpose it on
images of rural-looking Aborigines. The Enlightenment point of view,
Bennett suggests, quite literally cannot see Aboriginal people.

These paintings imagine new kinds of knowledge that are not rooted
in hierarchy. Interestingly, Bennett has commented that he would like
his paintings to appear in textbooks, replacing the images he himself
grew up with. One of his paintings, *Terra Nullius*, is subtitled "Teaching
Aid." This seems particularly fascinating, as it would be very difficult to
imagine his paintings, often conceptual and abstract, intellectually tena-
cious and provocative, in textbooks dominated by realist and narrative
imagery and synoptic, consensus-oriented treatments of subject matter.
But Bennett is working toward a new horizon of aesthetic and intellec-
tual endeavor. He is striving here for an integration of genres and forms,
a radical integration of pedagogy and aesthetics. This is precisely the
point. Ultimately, Bennett points to a new relationship to the production
of knowledge, one that would have ramifications at every level of the
educational experience, that would both deconstruct dominant knowl-
edges and also open up space for new kinds of knowledge, history, and
experience.

ARNALDO ROCHE-RABELL

We move now to Puerto Rico and the work of Arnaldo Roche-Rabell. Roche-Rabell has worked during a period of intense anxiety over the fate of Puerto Rico as a commonwealth of the United States. He was born in Puerto Rico in 1955, three years after the island was "allowed" to adopt its own constitution, which allowed self-governance but stipulated a dubiously termed "voluntary association" with the United States. Writ large, his oeuvre documents multiple efforts to come to terms with the complex and often contradictory social, economic, and cultural questions surrounding the island's future.

Roche-Rabell's paintings are extraordinarily dense, both in content and execution. His canvases typically foreground multiple deeply buried and intertwined figures. Indeed, it is often difficult, at first glance, to recognize figures in paintings such as *I Can't Make Miracles* (1993), in which a gaped-mouth black face is lodged sideways in a man's forehead, or *Let Me In* (1987), in which a shadowy figure seems to triumphantly rise from the head of a dark-skinned man.

To achieve this effect of obscured imagery, Roche-Rabell takes actual objects (including the bodies of living people) and then applies multiple levels over them. This is followed by "intense scratching or digging through layers of dry or partially dried paint." Indeed, according to Robert Hobbs (1996), Roche-Rabell works "with the concentration of an archeologist to reveal glimmers of an inner light" (p. 11). The journey, however, is not to restore the object to its original plenitude; at best, we can see glimmers of some sort of "light" in the process. Roche-Rabell, like Morrison and Harris, rejects any kind of final claim over definition, valuing the search in and of itself.

The intense struggle of becoming that his paintings formally evidence also reflects Roche-Rabell's understanding of the fate of Puerto Rico as a whole. The experience of Puerto Ricans in Puerto Rico is a constant state of becoming, forming, and re-forming. In his art, figures constantly doubling, emerging from other figures, and being lodged in other figures give a sense of a never-ending process. The sense of personal struggle we see in Roche-Rabell's work is, in many respects, the struggle of Puerto Rico itself. Roche-Rabell does not give us easy answers to the quandaries of Puerto Rico's fate. Hobbs, who introduced a recent exhibition of paintings titled *Arnaldo Roche-Rabell: The Uncommonwealth*, writes,

Uninterested in turning art into a politically partisan tool and far too subtle to adopt unconditionally any proposed solution for Puerto Rico's future or merely to censure the United States' actions vis-à-vis the Commonwealth of Puerto Rico, Roche-Rabell has taken an independent route in his art in which he looks at the nature of his associations with these two geographic entities and the post-colonial task of breaking down the binary opposition of imperial discourse that centers power and marginalizes the oppressed. (1996, p. 6)

Many of the struggles around Puerto Rico's survival and fate are linked to the topic of race, which has taken on a particular kind of instability on the island. As we have argued elsewhere, race is a construct that is mutable, open to different meanings in different contexts (Dimitriadis & McCarthy, 2000). Puerto Rican racial identity falls along a spectrum, from the white descendants of colonial Spain through the indigenous Indian (Taino-Arawak) population and the *mestizo* or mixed white-indigenous people to the dark-skinned or black Puerto Ricans, many of whom descend from African slaves. Race has been a symbol through which critics have debated how best to conceive of Puerto Rico's future. Jose Gonzalez (1993), in a particularly important intervention in this debate, argued that the fate of Puerto Rico needs to be built from "the ground up," where the ground is the experiences of black Puerto Ricans. He compares Puerto Rico to a four-story house. The first story is composed of the black African-Caribbean inhabitants of the island; the second, immigrants from South America and Europe; the third, occupants from the North American colonization beginning in 1898; and the fourth, present-day inhabitants, resulting from moves toward industrialization in the 1940s. Gonzalez argues, again, that the first story, the black ancestry, must be drawn upon in the process of "decolonizing" Puerto Rico and forging a new future.

In his famous response to Gonzalez's highly structured model, Juan Flores argues for a much more fluid notion of identity. Flores (1993) writes,

Rather than the floor-upon-floor blueprint suggesting successive layers, a concept of cultural history as the constantly interpenetrating dynamic of traditions and social practices makes for a more satisfactory guiding principle of interpretive analysis. For example, rather than merely locating Afro-Caribbean culture at the origins of Puerto Rican nationality, it is necessary to study how this basic strain of popular culture is reconsti-

tuted, taking on new meanings and socio-cultural functions, in the vary-
ing contexts of national history—before and after the abolition of slav-
ery; in its differentiated contact with indigenous, European and North
American cultures; in relation to an emerging working class cultural life
on the island; and in the racially new setting of the urban United States.
The mechanical analogy of architectural construction tends to lock any
given aspect of the national culture into the confines of its initial mani-
festation. (p. 69)

Flores argues for a more dynamic notion of cultural inheritance, one that
is open to the multiple meanings and uses to which Puerto Rican racial
identity can be put.

Roche-Rabell offers a similarly complex theorization of race and the
fate of Puerto Rico in paintings such as *Asabache* (1986), *Poor Devil*
(1988), *I Can't Make Miracles* (1993), and *I Want to Die as a Negro*
(1993). These canvases foreground a kind of twinness or doubleness
around race. The first two paintings, for example, depict blue-eyed black
faces, pointing to the doubleness inherent in Puerto Rican identity. In
Asabache, the head has protruding horns, echoing a theme of Morrison's
The Bluest Eye, where a young girl wrestles with her own demons—her
internalized white ideals. In *I Can't Make Miracles*, a white man's head
is bowed in his hands, seemingly in desperation. Black hands are overlaid
on his white hands, while a black man's face is lodged sideways in his
forehead. In promoting the concept of the twinness of self, Roche-Rabell
lodges a trenchant critique of the rigidities of identity and affiliation of-
fered in the capitalist-organized society, even in a peripheral country such
as Puerto Rico. Through his multilayered paintings, Roche-Rabell imag-
ines a starting point for new, politically reconfigured communities.

From the mutability of race, Roche-Rabell moves to the anguished
question of historical responsibility in *I Want to Die as a Negro*. In this
frontal and symmetrical composition, an African mask lies upon a black
subject's solemn-looking face, which is flanked by two upraised and dou-
bled black fists. The image evokes pan-African nationalist notions of
identity. Yet in its very title, Roche-Rabell foregrounds the degree of
choice involved in how we live out our racial inheritance. His choice is
to die among the oppressed, in struggle. Race is not a category given, *a
priori*. Roche-Rabell's theoretical move here is to take us away from
static notions of cultural origin and identity to more dynamic ones con-
nected to political concerns, questions, and obligations.

Roche-Rabell, in short, suggests that race is a fluid marker of social distinction and that how we live out our racial inheritance is explicitly political. However, as Hobbs notes, he does not have a prefigured political platform. Rather, there is a profoundly deliberative process at work here. We quite literally see rebirth in paintings such as *Take Over* (1985) and *Let Me In* (1987), where figures struggle triumphantly out of the heads of black men. We see multiple political possibilities in paintings such as *Father Tell Me If You Love Me* (1995), in which a subject holds multiply entwined strings between his fingers in what looks like a child's "cat's cradle," while U.S. Capitol buildings stand on either side of him, in the background. The abiding connections between the United States and Puerto Rico, these works suggest, run too deeply to be easily wished away even by concentrated political action.

Like Bennett, Roche-Rabell opens up questions without foreclosing political possibilities. He also acknowledges multiple inheritances—from van Gogh to the work of Puerto Rican painters such as Osiris Delgado and Carlos Raque Rivera. As a public intellectual, Roche-Rabell, like Bennett, draws on a range of resources in order to offer complex notions of what personal and political becoming can mean, as well as how they are linked.

JEAN-MICHEL BASQUIAT

We now consider the work of Jean-Michel Basquiat. Basquiat's work is striking, and strikingly different from both Bennett's and Roche-Rabell's. Bennett's work foregrounds cool lines of vision and perspective, interlaced with the staccato style of Aboriginal pointillism, reconfiguring representational tradition; Roche-Rabell's work is densely layered and textured while acknowledging a tradition of allegorical painting; Basquiat's work, in contrast, is improvisational and frenetic. There is no pretense to naturalism, as he deploys cartoonish or childlike images, signs and symbols. Ultimately, Basquiat was a child of American popular culture as well as European and African American traditions.

Like Bennett and Roche-Rabell, Basquiat has a complex family history—his mother was Puerto Rican while his father was Haitian. Basquiat wrestled with his complex personal and political positioning throughout the course of his brief career. While he clearly had an anti-racist political agenda (see *Obnoxious Liberals* [1981], and *Irony of Black*

Policeman [1981], among others), he was not confined to the stable cultural identity of "blackness." Indeed, of all the artists discussed so far, Basquiat is the most explicit in his mixture of high and low cultural signifiers. He refers to, among other sources, Charlie Parker, Leonardo da Vinci, Batman, Captain America, opera, James Joyce, and Billie Holiday in forging his canvases. He has collaborated with Francesco Clemente and Andy Warhol as well.

Basquiat's impure mixture of sources speaks to contemporary debates about cultural purity, debates that are especially heated in anthropology. Renato Rosaldo (1993), in his powerful *Culture and Truth*, argues that anthropology has traditionally been conceived of as an "art museum," where artistic products from distinct cultures are put on display for easy consumption by all. In this view, "Cultures stand as sacred images; they have an integrity and coherence that enables them to be studied, as they say, on their own terms, from within, from the 'native' point of view" (p. 43). While this approach was part of an anthropological agenda that, at least in part, resisted the racism of Eurocentric elites, a static picture of culture has resulted. Rosaldo argues instead for the notion of culture-as-garage-sale, "where cultural artifacts flow between unlikely places, and nothing is sacred, permanent or sealed off" (p. 44). Basquiat's work embodies this ethic, defying cultural containment in both content and form.

New York City itself was Basquiat's canvas early in his career. For many years, he painted nonsensical phrases such as "Plush Safe— He Think" around the city, signing his graffiti as "SAMO." Much of the initial interest in Basquiat, in fact, gelled around his connection with the then-burgeoning graffiti art scene in New York. As the quasi-documentary *Wild Style* (1982, directed by Charlie Ahern) makes so very clear, there has always been an uneasy relationship between the "downtown" art scene in New York and the "uptown," primarily black and Latino, hip-hop scene. The art world's fetishizing of the work of nonwhite artists, assumed to be "the voice of the street," marked Basquiat's career for better and worse and is reflected upon ironically in his work.

Basquiat's father, as noted, was Haitian, while his mother was Puerto Rican. Just as Roche-Rabell as a Puerto Rican wrestled with his "blackness," so did Basquiat. On one level, his work was collected and validated in a context that fetishized his "blackness," especially vis-à-vis the nascent hip-hop scene in New York City in the late 1970s and early

1980s (Basquiat himself produced a rap single). He was used by (and used) an art market that fetishized and hyperbolized him as the "first great black American painter." Yet he was always uncomfortable with the notion that he was a "black painter" and struggled with the accompanying paternalism. His struggle is common to other postcolonial artists, who simultaneously operate within and challenge the identity matrixes into which they are thrust.

Basquiat's work reflects the complexity of the contemporary cultural moment for nonwhite people in the United States and around the globe. Indeed, it would be all but impossible to understand Basquiat's work without understanding jazz music, or the work of classical Italian painters, or the influence of comic book superheroes. Like the artists discussed earlier, Basquiat avoids "folk" notions of identity and culture, as evidenced by wry titles such as *Undiscovered Genius of the Mississippi* (1983) and *Revised Undiscovered Genius of the Mississippi* (1983). Both comment upon the "moldy fig" ideal of classical ethnomusicology, where searching for "authentic" blues means searching for obscure, "old . . . blind, arthritic, and toothless" performers to discover and promote (Keil, 1966, pp. 34–35). Yet jazz figures like Charlie Parker and Louis Armstrong are very much a part of this inheritance, as evidenced by paintings such as *Charles the First* (1982) and *Black* (1986). However, so are Batman and Captain America, who appear in numerous paintings, including *Riddle Me This Batman* (1987) and *Mitchell Crew* (1983). And so is da Vinci, who is featured in Basquiat's ironically titled *Greatest Hits of Leonardo da Vinci* (1982). Tradition is an unfolding and dynamic process for Basquiat.

We draw particular attention to *Charles the First* (1982), a painting whose very title points both to the kingly status of the jazz great Charlie Parker as well as to the ultimate futility of being "the first" anything in jazz. The point is driven home by the reference to "Cherokee," a standard pop tune written by Ray Noble, which would be revised by Parker as "Ko-Ko" and "Marshmallow." The futility of origins is evidenced as well in the wry "copyright" logo placed dead center in the middle of the second panel. Destabilizing the authority of origins is a technique crucial to postcolonial artists attempting to envision a third or intertextual space of form. Basquiat captures the energy of Charlie Parker (and others), in large measure, through the frenetic juxtaposition of high and low cultural signifiers. As in much of his work, references to superheroes are scattered throughout the piece—for example, the Superman "S" (which

appears twice), as well as the words "Thor" and "X-Mn" (a reference to the X-Men comic book). In addition, the words "Marvel Comics," crossed out, with a copyright symbol next to them, adorn the bottom of the third panel. These are juxtaposed with a reference to opera (the most elite of art forms), as well as to Parker's raised left hand, a near holy—though thoroughly secular—sign.

Like Bennett and Roche-Rabell, Basquiat mobilized this complex cultural inheritance to address social concerns both local, as in *Irony of a Negro Policeman* (1981), and global, as in *Natives Carrying Some Guns, Bibles, Amorites on Safari* (1982). In the latter painting, a native-looking African holding a box that reads "Royal Salt Inc." and a roughly sketched man in a pith helmet stand side by side. The phrase "Good Money in Savages" and the words "kin" and "Tusk$" are among the many that adorn this frenetic painting, a painting that skewers economic and religious colonization.

Basquiat's work can be a valuable tool for educators today, acknowledging, as he does, the range of resources young people draw on in constructing their identities. Drawing with a vigorous irony on his complex cultural inheritance, Basquiat challenges the authority over identity that so many multicultural educators claim.

CONCLUSION

Bennett, Roche-Rabell, and Basquiat all resist the anthropological model of culture upon which educators have drawn. Multicultural educators, in particular, have continually offered different models for looking at the nature of cultural contact—the "melting pot" and the "salad bowl" are among the most famous. Though different in their vision of plurality, each of these models assumes a separation between different cultures and a pure originary space of culture. Such "authentic" notions of cultural inheritance have tended to both fetishize and marginalize the day-to-day realities of oppressed people. Stories of the oppressed are narrated within a linear model that contains their experiences in the past for ready and easy consumption.

The artistic practices of the three postcolonial painters discussed in this chapter offer us a more complex and satisfying theorization of cultural identity. Culture, for them, is an inherited set of resources, resources with histories, on which we all draw in constructing selves and

social relations. In problematizing the postcolonial condition, these painters offer us critical tools to think through the ethics of our modern existence. They encourage us to rethink how we understand the world in which we live, particularly the knowledges of our human environment that we produce for the edification of ourselves and others.

"Dangerous Crossroads" of Performance and Pedagogy in Global Youth Culture

We have looked so far at some of the ways that educators can draw on art forms—the novels of Wilson Harris and Toni Morrison, the paintings of Gordon Bennett, Arnaldo Roche-Rabell, and Jean-Michel Basquiat—in thinking through key questions about knowledge, culture, community, and identity. We conclude this exploration of the aesthetics and pedagogy of postcolonial art forms with a discussion of music-making and performance practices. In moving to the terrain of music and performance, we are reminded of Baldwin's intense engagement with the recordings of Ma Rainey, Louis Armstrong, Bessie Smith, and Paul Robeson; Toni Morrison's stunning layering of time and improvised voices in *Jazz*; Basquiat's engagement with hip-hop, jazz, and blues in *Charles the First, Black*, and *Undiscovered Genius of the Mississippi*; and finally, C. L. R. James's fascination with Caribbean calypso and "classical" European music. James, in particular, enjoyed both performing and critically analyzing classical and popular music. This is well documented in his correspondence to Constance Webb in *Special Delivery* (1996) and in essays such as "The Mighty Sparrow" (a calypso artist) and "Paul Robeson Black Star," in *The Future in the Present* (1980a, pp. 191–201) and *Spheres of Existence* (1980b, pp. 256–264), respectively. At one moment, one can find James spontaneously rendering Mozart arias in the heights of camaraderie with the crewmen abroad a ship in the Gulf of Mexico on his way to the United States from one of his visits to Trotsky in Mexico. At another, James writes thoughtful letters to Constance Webb about the way in which a Mozart or Beethoven concerto works (James, 1996). All (and others) evidence the overwhelming, near-constitutive, and often unpredictable ways in which music has informed the postcolonial aesthetic.

In this chapter, we focus more clearly on contemporary popular music and performance practices, arguing that these are the product of multiple, overlapping, and complex cultural trajectories. Artists today have at their disposal a rich and varied archive of recorded material for creative

appropriation. From rap music sampling to the new links between world music and dance culture, musicians today are conjuring up and creating new kinds of social affiliations that challenge the ready-made theoretical constructs of educators and pedagogues alike. Youth music today is a dizzying blend of genres and styles that belies the ability of record companies to easily target and commodify it. According to Timothy Taylor (1997),

> One of the most notable trends in the music industry since the 1980s has been the rise in popularity of new music genres: world music, world beat, world fusion; in Germany, *Weltbeat* and *Weltmusik*; in other parts of the world, ethnopop, Afropop, Afrobeat. Offshoots of these genres include: tribal, techno-tribal, and cybertribal, as well as ambient, trance, and new age. (p. 1)

This proliferation of music styles and genres has opened up new avenues for identity and identification. Take, for example, the case of Bhangra, which, drawing largely on traditional Indian Punjabi music, helped constitute a new kind of Anglo-Asian identity in Britain. Artists like Apache Indian have creatively linked Bhangra to Jamaican dancehall reggae to help form "bhangramuffin," which has been part of fashioning an Afro-Asian affiliation that speaks to some of the realities of living in the hybrid space that now is England. The appropriation and reappropriation of music styles has resulted in a proliferation of local music scenes—"syncretisms and hybridities, which themselves syncretize and hybridize" (Taylor, 1997, p. xv). In particular, we see local stylistic appropriations, which have opened up new avenues for fashioning new kinds of identities and identifications. We argue that these creative uses of music are most evident in the context of dance and dance music, music that is DJ-driven and is constituted and reconstituted on the dance floor, its central "point of production."

Our discussion here serves to highlight the central, if thus far understated, role of "performance" throughout this book. The carnivalesque in Harris, the reconfiguring of history in Morrison, and the complex theorization of culture and identity in the paintings of Bennett, Roche-Rabell, and Basquiat all foreground people's agency in sustaining and transforming constructions often deemed immutable—community, culture, identity. All of these must be created and sustained in local and

often unpredictable kinds of ways in this age of economic, social, and cultural globalization.

Yet the notion of "performance" has had, of course, a particular valence for music. Indeed, a performative ethic can be traced historically across African and Latin music-making practices, where the line between performer and audience has traditionally been open to negotiation. These largely improvised musics have relied, in particular, on the work of dancers to maintain and sustain them, a point made over the last several decades by ethnomusicologists such as Charles Keil, Christopher Small, and John Chernoff. As we will demonstrate, this ethic very much informs contemporary DJ-driven dance musics, which rely less on individual, iconic musicians than on engaged dance crowds and draw on a broad and disparate archive of recorded musics. We highlight here the new modes of association being constituted through dance music. Specifically, we highlight notions of community that exceed the authoritarian ones often privileged in schools today. We see resources for educators to reflect on community—what it means, how it can form, and how it can be sustained—in this, our global postmodern moment.

GLOBALIZATION AND THE PROLIFERATION OF RECORDED MUSICS

Globalization disconnects place from given notions of culture and identity, creating multiple possibilities for new cultural formations. "Disembedded cultural practices," we argue, are being deployed in ways which open up "new complex hybrid forms of culture" (Tomlinson, 1999, p. 141). Following James Clifford, we can no longer look at "roots," that which link us inextricably to place, but must look toward "routes," rhizomatic lines of connection and association (Clifford, 1997). Of course, this idea has been brilliantly demonstrated by Paul Gilroy in *The Black Atlantic* (1993). Gilroy suggests that a critical signifier of the dynamic diasporic movement of black identities is the multivocality and syncretism of black popular aesthetics, particularly music. Black diasporic identities and cultures, according to Gilroy, and also Bhabha (1994), are performative. They must be created, maintained, and sustained—something we saw quite clearly in the work of Bennett, Roche-Rabell, and Basquiat. We must continually perform our identities as we must create and sustain our relationship to specific sites and spaces.

Globalization throws into sharp relief the contemporary proliferation of "media cultures" (Kellner, 1995). The fact of media reproducibility separates music texts from those creating them, opening them up to both transformative and venal reappropriation. Steven Feld (1994) takes up these concerns in "From Schizophonia to Schismogenesis: On the Discourses and Commodification Practices of 'World Music' and 'World Beat,'" in which he stresses that a wider and wider archive of recorded world music is available for use and recontextualization through the global proliferation of increasingly sophisticated reproductive technologies. Feld draws on the work of critics including composer Murray Schafer and critic Jacques Attali in reopening the perennial debate about the circulation of sound cut off from its originary sources. Music, to echo Benjamin and to underscore Feld, has largely lost its "aura" of originality, its ritual function, as it has entered the commercial sphere and been opened to multiple uses. This is a process that has taken place over the course of the 20th century, though it has become increasingly pronounced over the past two decades. According to George Lipsitz (1994), we find ourselves at dangerous crossroads:

> The interconnectedness of cultures displayed by world music is not without utopian possibilities, but the ravages of unimpeded capital accumulation create grave dangers as well. These crossroads are dangerous for all of us; how well we negotiate them may determine what kind of future we will face—or whether we will face any future at all. Dangers await at the crossroads, but never with more peril than when we refuse to face them. (pp. 19–20)

For Lipsitz and for us, artists and their constituencies who have been "down at the crossroads" and have come back with empowering visions of the future need more serious attention.

We recall here, in this evocation of "dangerous crossroads," the work of Detroit techno DJs Juan Atkins, Kevin Saunderson, and Derrick May. Beginning in the 1980s, these African American artists struggled to conjure up new kinds of communities in the wake of the ravages of deindustrialization and urban decay that hit Detroit particularly hard. Through a sophisticated and nuanced deployment of electronic technology—the technology of music sampling—these artists reclaimed a sense of community through dance while gesturing toward new kinds of futures. As Gilbert and Pearson (1999) argue, Atkins, Saunderson, and May "repeatedly referred to the influence of their immediate surround-

ings: 'techno' as a label alluded to the (problematic) industrial heritage of the 'Motor City', and its double valuation of technology, as both negative and positive" (p. 75). In the ashes of postindustrial Detroit, Atkins, Saunderson, and May all rest at the "dangerous crossroads" of contemporary youth culture as they evoke communitarian futures that are uncertain though replete with possibility. All took the self-same technologies that crippled this "Motor City" and redeployed them to create new kinds of communities. In this chapter, we examine the new models of association and activity these artists and their youthful constituencies have created.

DJ AND DANCE CULTURE

We would now like to focus on the case of hip hop, and the DJ and dance culture of which it is a part. Rap was originally one part of a performance-based art form that included dance and graffiti. Here, as discussed in Chapter 1, we see a fluid circulation of art forms that belie disciplinary separation. Indeed, it is interesting to note that Basquiat, that theorist and practitioner of the postcolonial urban moment, was an early DJ and also graffiti artist. Basquiat's participation in the African-American arts, it seems, was indicative of the heterogeneity of the hip-hop movement during the late 1970s and early 1980s. Taken as a whole, the movement integrated and interfaced painting, writing, dance, and music:

> Stylistic continuities were sustained by internal cross-fertilization between rapping, breakdancing, and graffiti writing. Some graffiti writers, such as black American Phase 2, Haitian Jean-Michel Basquiat, Futura, and black American Fab Five Freddy produced rap records. Other writers drew murals that celebrated favorite rap songs (e.g., Futura's mural "The Breaks" was a whole car mural that paid homage to Kurtis Blow's rap of the same name). Breakdancers, DJs, and rappers wore graffiti-painted jackets and tee-shirts. DJ Kool Herc was a graffiti writer and dancer first before he began playing records. Hip hop events featured breakdancers, rappers, and DJs as triple-bill entertainment. Graffiti writers drew murals for DJ's stage platforms and designed posters and flyers to advertise hip hop events. (Rose, 1994, p. 35)

Early DJ music was open to multiple kinds of influences. Early DJs, to invoke Grandmaster Flash, wanted to accentuate "the best parts" of records to keep the party going, playing records one over the other, back

to back. Hence, for example, the oft-noted use of Kraftwerk by Afrika Bambaataa in his classic track "Planet Rock" (1982). Kraftwerk was a German group that was by no means funk- or dance-based but used dense electronic synthesizer sounds on albums like *Autobahn*, released in 1974. That this recording by a German electronic band could be constitutive of black popular culture in the United States, radically reworked as a resource for Bambaataa's Zulu Nation, speaks to the increasing complexity of cultural appropriation. Indeed, Derrick May also noted, quite famously, that Detroit techno was akin to [funk musician] "George Clinton and Kraftwerk stuck in an elevator." This is one example of the richness of origins of today's DJ- and producer-based musics, which juxtapose and cross-cut sounds in exciting and innovative ways. The use of samples in rap has become remarkably sophisticated, as many critics of music and recording technologies point out (Theberge, 1998).

While rap has become increasingly commodified with, for example, the growing proliferation of so-called "gangsta rap," DJ culture has been its most lasting musical legacy. Indeed, DJ music has been invented and reinvented in different contexts around the country and around the globe—musics such as tribal, techno, jungle, and ambient; among black youth in Britain, gay youth in Chicago, and around the world from Tokyo to Goa. These musics take an irreverent attitude toward origins and thus are increasingly open to audiences that are increasingly difficult to prefigure. If genre boundaries serve the imperatives of industry more than they do music fans, then dance music has cross-fertilized with world musics in ways that make dance music increasingly difficult to understand for those outside of it (Reynolds, 1999; Walser, 1993).

In fact, dance music has been largely ignored in extant cultural criticism, both popular and academic. Perhaps Simon Reynolds is right when he notes that there is an inverse relationship between the vibrancy of a music scene and the amount of criticism devoted to it. Yet a more general reason, we think, is the fact that dance musics are not text-driven art forms, which mark them as different from more dominant popular cultural productions. Gilbert and Pearson (1999) make a similar such point:

> There is a significant split between accounts which privilege the metaphysics of presence and those that prize their distance from the topic in question. Writing about social dance further widens this fissure, in the sense that the act of writing could be said to represent as absolute

a withdrawal or contrast from the act of dancing as is possible to achieve. (p. 17)

TEXTUAL ANALYSES AND PERFORMANCE

Both pop and classical strands of music criticism tend to emphasize textual analysis to the exclusion of other kinds of criticism (Dimitriadis, 1999). Informed by various strains of formalism, textual criticism assumes that music is self-contained and exists outside the variances of live production and performance. It assumes music to be fully decipherable—an assumption that has been made of "high art" and extended to popular art traditions. This textual approach has its roots in structuralist models of communications, which tend to assume that all necessary context can be located in the texts themselves. Simon Frith (1996) echoes these concerns in his treatment of classical American composer Leonard Bernstein:

> [Leonard Bernstein's] question is *how* does music communicate (which is, for him, a prior question to what it does), and his starting assumption is that it must "mean" the same thing to composer, performer, and listener, otherwise communication would be impossible. In investigating this problem Bernstein draws on linguistics, on Chomskyan linguistics, in particular, on a theory of what makes communication *possible*: an underlying human capacity to grasp the "deep structure" of the communication process. (p. 104)

Like many classical composers, Bernstein draws on a deep structure communicative model, one that assumes that *langue*, the general language system independent of individual users, is far more important than *parole*, or local variations to language use. This deep structure is thought to transcend particular performances.

Western music criticism has largely imported the *langue* model and thus has remained locked into textual kinds of criticism. The score or recording has remained the primary unit of analysis, while particular performances in historical context are relegated to the sidelines. Recently, however, music critics such as Charles Keil, John Chernoff, and Christopher Small have challenged the structural logic that dominates music criticism, pushing the field toward more situated understandings of performance and music process. Keil argued in the early 1960s that the

tools that music critics typically draw on are grounded in a particularly European "high art" understanding of what music is all about. In his classic discussion of Leonard Meyer's *Emotion and Feeling in Music*, Keil (1994) writes:

> [Meyer's] procedure assumes that for analytic purposes music can be fixed or frozen as an object, a score or a recording, and it implies not only a one-to-one relationship between syntactic form and expression but a weighting in favor of the former to the detriment of the latter. (p. 54)

Music is removed from its situated context and treated as a self-contained "fixed or frozen" object, one that can be explored and evaluated on its own. As Keil argues, such an approach equates form and expression: All the important relationships can be traced or explored between the notes themselves. It is all on the page, so to speak. Meaning or musical affect can be located within the score or recording itself, regardless of local contexts of use.

These formalist assumptions have been used to illuminate an entire tradition of "classical" European score-driven music. However, these approaches, as Keil argues, have been particularly unhelpful in illuminating non-elite Western musics, which rely on performance for their ultimate realization. These musics—like most popular musics rooted in dance—have been wholly ignored in the Western academy until recently (McClary, 1994). Keil (1994) goes on:

> In some music, and I am thinking specifically of African and African-derived genres, illumination of syntactic relationships or of form will not go far in accounting for expression. The one-to-one relationship postulated by Meyer will not hold; syntactic analysis is a necessary condition for understanding such music, but it is not in itself sufficient. (p. 54)

Musical/performative relationships are not fully contained or realized in the syntax alone. They cannot be captured in ideal form, out of context.

To understand these musics, we must take the performance itself as the primary unit of analysis, expanding it to encompass all the activities that constitute the event itself. This means appreciating all the ways various participants conspire to sustain the event, from musicians to listeners to dancers. Musical practices, like all collective activities, are sustained by particular communities in particular times and places, and must be

understood as such. Howard Becker's *Art Worlds* (1982) is quite helpful here. Becker critiques the idea that art is created by isolated artists in historical vacuums. He writes, "All artistic work, like all human activity, involves the joint activity of a number, often a large number, of people" (p. 1). Becker stresses that participants share in the construction of artistic events. The autonomous artist, creating his or her work in isolation, secluded from the vibrancy and variance of the social, is largely a fantasy of Western aesthetic criticism (and a particularly regressive one at that). More people than the musicians alone count here. Understanding the role of the audience as active agents becomes increasingly important for understanding the music-making activity.

Christopher Small takes a similarly activity-centered approach in *Music of the Common Tongue: Survival and Celebration in Afro-American Music* (1987). He notes here that "music is not primarily a thing or a collection of things, but an activity in which we engage," continuing, "I define [musicking] to include not only performing and composing . . . but also listening and even dancing to music; all those involved in any way in a musical performance can be thought of as musicking" (p. 50). Indeed, Keil and others have stressed that many non-elite non-Western musics cannot be understood outside of their relationship with dance, something that can be said for most popular musics as well (see McClary, 1994). As John Chernoff (1979) writes, African music is, quite literally, only realized through the participation of dancers:

> In African music, it is largely the listener or dancer who has to supply the beat: the listener must be *actively engaged* in making sense of the music; the music itself does not become the concentrated focus of an event, as at a concert. It is for this fundamental reason that African music should not be studied out of its context or as "music": the African orchestra is not complete without a participant on the other side. (p. 50)

Dancers do not simply accompany drummers as they perform. Rather, dancers become integral parts of the music-making processes, supplying an additional rhythm, through the pounding of their feet, to the polyrhythmic event. Rhythms play off of each other, dancers interacting with drummers and drummers with dancers; all are responsible for sustaining the event.

As such, dance cultures, broadly understood, open up many ways for artists and audiences to interact with each other, moment to moment. These include world musics, non-Western musics, and contempo-

rary DJ-driven dance musics—all of which have filtered into each other
in fascinating ways (Taylor, 1997). In these varied arts, there is no clear
separation between those onstage and off. Like the African drummers
discussed above, the contemporary DJ is not the sole focus of creative
endeavors—an "auteur"—but is one part of an interactive, performative
network that includes audiences, other artists, and technologies. We
don't see the same popular star system at work here as in other popular
musics today, such as "rock." The DJ is not necessarily marketed as a
commercial icon, and mixing music is not necessarily a means to produce
"tracks." As Reynolds (1999) argues, critical approaches that center on
the product or the artist are useless for understanding this music, as they
are for the non-Western musics discussed earlier:

> This is how rock critics still tend to approach dance music: they look
> for the auteur-geniuses who seems most promising in terms of long-
> term, album based careers. But dance scenes don't really work like this:
> the 12-inch single is what counts, there's little brand loyalty to artists,
> and DJs are more of a focal point for fans than the anonymous produc-
> ers. (p. 4)

Recordings that make "sense at home and at album length" (Reynolds,
1999, p. 4) are not the lifeblood of participatory dance scenes. Dance
music invites participation at specific sites, times and places. One learns
by doing, by helping to sustain the event. Dance is "legitimate peripheral
participation" (Lave & Wenger, 1991).

IMPLICATIONS FOR EDUCATION: HONORING THE
PEDAGOGICAL VISION OF CHRISTOPHER SMALL

Christopher Small, in his classic *Music, Society, Education* (1977), brings
these participatory concerns to the realm of education, advocating for
the ethical and social importance of the participatory arts. They contrast
directly with European music, he argues, which is about the ritual instan-
tiation of control and mastery, authority and submission, and is but-
tressed by an education system with similar imperatives. While European
classical music can indeed be understood as a complex "performance,"
according to Small, it reifies the role of the performer and the nature of
the interaction. The interaction privileged is an authoritarian one, where
the composer controls the conductor, who controls the musicians, who

all control the audience. The audience here is encouraged not to interact but to be still, silent, and obedient.

These kinds of relations are mirrored, Small argues, in dominant educational practices today.

> It has been often pointed out that the very physical structure of the orthodox classroom, which so resembles that of the orthodox concert hall, with its rows of desks facing the blackboard and the teacher, making interaction possible only between teacher and pupil, never between pupil and pupil, makes clear, before a word has been uttered, the direction from which knowledge it to come. . . . Textbooks, blackboards and the majority of what has become known as educational technology all serve to confirm the pupils as consumers of knowledge, as do examinations, to which, acknowledged or not, the learning activity is directed. (1977, p. 185)

This system conceives of students, to echo Freire (1970), as empty containers to be filled by the teacher. This is the "banking" concept of education. The student is assumed to be submissive to the teacher and to have nothing to contribute to the meaning of the pedagogical experience. The student is by this arrangement a consumer of knowledge, not an initiator or creator. Knowledge as such is considered to exist outside of and independent from students. Here, according to Freire, "the teacher talks and the students listen," "the teacher disciplines and the students are disciplined," and "the teacher chooses and enforces his choice, and the students comply" (p. 54). Participatory music practices offer another model, one that encourages producer–audience collaboration and encourages learning by doing, by becoming a member charged with sustaining the dialogic encounter. In the participatory model of education—indeed, of reality—the world is made by invested actors in dialogue, in the process of transformative action.

The participatory model offers educators a different theory about what constitutes learning and how and where it happens. For Small and others, musics of the Third World and the periphery of the first offer a more humane model for being in the world, which stresses not mastery and control but graceful coexistence. When we take such an approach, we cannot prefigure what the world will look like, and instead must engage with multiple kinds of audiences in an increasingly unpredictable public sphere. Music and performance give us models for this kind of dialogue. "What defines the political character of dance culture," Gilbert

and Pearson (1999) argue, "is that it is not afraid of the future. Its re-
sponse to the dislocation of social structures is not simply despair, the
celebration of atomization, or a reactionary attempt to recreate lost co-
herencies, but an attempt to make possible new forms of community and
new networks of relation" (p. 184).

We thus see an overlap between the musics discussed by Keil, Small,
and Chernoff beginning in the 1960s and contemporary DJ-driven
dance music. And we are not alone. Critically, musicians and producers
themselves are seeing—and theorizing—similar such connections, as evi-
denced by recent CD releases such as *The Afro Celt Sound Systems, Vol-
umes 1 and 2* (released on Real World Records). Even a cursory glance
at contemporary world and dance music reveals the circulation of global
themes and tropes in exciting, important, and often counterintuitive
ways, in ways that open up new kinds of identifications.

CONCLUSION

In closing, we see an intense search for new modes of association, new
kinds of community, evoked in the context of contemporary music-mak-
ing. We, as educators, need to pay close attention to these emerging
tendencies. We need to see young people as creative agents charged with
producing, sustaining, and maintaining new networks of affiliation. Yet
evoking the conditions for these networks and new kinds of community
requires us to reconsider how we organize and stratify knowledge into
disciplines. If we acknowledge young people and their creative powers,
Small (1977) writes, "we must also recognize their ability to create other
forms of knowledge . . . and to ask their own questions, which often
cross the boundaries of our own treasured subjects and specialties" (p.
216). Small's rousing call to educators brings us to the vital question of
how the work of art in the postcolonial imagination may inform funda-
mental change in educational disciplines and institutions, the topic with
which this book will close.

Beyond Postcolonial Aesthetics

Facing Educational Challenges in the New Millennium

Earlier in this book, we discussed the role of black diasporic public intellectual activity in the middle part of the 20th century, focusing on the lives and work of James Baldwin and C. L. R. James. We argued that these intellectuals were critical pedagogues and public intellectuals of the highest order. We turned, in the ensuing chapters, to the pedagogical work of other postcolonial artists: novelist Wilson Harris on the curriculum; Toni Morrison on history; painters Arnaldo Roche-Rabell, Gordon Bennett, and Jean-Michel Basquiat on tradition; and dance culture DJs and musicians on community. These critically conscious intellectuals and artists, in different ways, negotiated the worlds of establishment aesthetics and popular or vernacular cultural life outside educational institutions, fashioning a curriculum of popular instruction that challenges contemporary center–periphery relations wherever they are to be found. Their works of textual production, visual art, and performance-based practices serve as models of critical thought and action—crucial examples for educators as they attempt to understand the increasingly complex social, cultural, and material reality of modern school life. This complex reality, we argued, is being driven forward by the powerful dynamics of globalization—mass migration, the work of the popular imagination, and electronic mediation—the domains of semiotic production and textual production, popular culture *tout court*. These developments have heightened the presence of multiplicity and difference in the American social context as a whole and in education in particular, even while educators have been inclined to narrowly interpret their implications for curriculum and pedagogy.

Given these dynamics, then, and as we have maintained throughout, it is extremely difficult to separate the logic of school life from the logic

of popular culture writ large. In particular, as we first indicated in the Introduction, educational institutions seem ever more in synch with popular culture in their incorporation and mobilization of multiplicity and difference, in their constant fabrication of racial identities through the production of "pure" spaces of racial origins. We see "ressentiment"— the process of defining one's identity through the negation of the other—as the overarching, defining trope here. This trope of ressentiment is articulated further as a set of strategies or discourses that are deployed in institutional and popular culture to manage the heightened presence of multiplicity and difference in contemporary American life— weaving together ever-new patterns of affiliation and exclusion, incorporation and insulation, in cultural and knowledge practices. In this final chapter, we would like to ask: How can the critics and artists engaged in postcolonial aesthetics help us to confront the hegemonic thinking about multiplicity and difference that has now seeped into the popular imaginary and social and educational life, even in "alternative" discourses such as multiculturalism? How can the work of the postcolonial imagination help us buck a growing tide of ressentiment in education today? We call attention to three discourses of ressentiment now operating in media culture, where popular narratives now perform the vital role of public instruction on multiplicity, difference, and change. We also show how these popular discourses are mirrored by parallel discourses in education as well. We then turn to the particular salience of ressentiment in school life today. And we conclude by pointing to the path that postcolonial art offers us beyond ressentiment and the dominant curriculum in schooling.

THREE DISCOURSES OF RESSENTIMENT

First, we would like to call attention to *the discourse of origins* as revealed, for example, in the Eurocentric/Afrocentric debate over curriculum reform. Discourses of racial origins rely on the simulation of a pastoral sense of the past in which Europe and Africa are available to American racial combatants without the noise of their modern tensions, contradictions, and conflicts. For Eurocentric combatants such as William Bennett (1994) or George Will (1989), Europe and America are a self-evident and transcendent cultural unity. For Afrocentric combatants, Africa and

the diaspora are one "solid identity," to use the language of Molefi Asante (1993, 1997). Proponents of Eurocentrism and Afrocentrism are themselves proxies for larger impulses and desires for stability among the working and middle classes in American society in a time of constantly changing demographic and economic realities: The immigrants are coming! Jobs are slipping overseas into the Third World! Discourses of Eurocentrism and Afrocentrism travel in a time warp to an age when the gods stalked the earth. The dreaded line of difference is drawn around glittering objects of cultural heritage and secured with the knot of ideological closure.

The modern American school, much like the theater of popular culture, has become a playground for this war over symbols, knowledge, and experience. And contending paradigms and schools of thought are embattled as combatants release the levers of atavism, holding their faces in their hands as the latest volley of absolutism circles in the air. This was recently evidenced by the fierce and highly publicized debate over Martin Bernal's *Black Athena: The Afroasiatic Roots of Classical Civilization* (1989), sparked by Mary Lefkowitz's *Not Out of Africa* (1997) (see also Berlinerblau, 1999). Lefkowitz charged that Bernal's canonical Afrocentric text was based on historical inaccuracies, accepted only in the name of "political correctness." The debates that ensued reinforced the stark Eurocentric/Afrocentric divide referenced above.

A second ressentiment discourse at work in popular culture and contemporary life is *the discourse of nation.* This discourse is foregrounded in a spate of recent ads by multinational corporations such as IBM, United, American Airlines, MCI, and General Electric (GE). These ads both feed on and provide fictive solutions to the ethnic tensions and racial anxieties of the age. They effectively appropriate multicultural symbols and redeploy them in a broad project of coordination and consolidation of corporate citizenship and consumer affiliation. Hence, the GE "We Bring Good Things to Life" ad (which is shown quite regularly on CNN and ABC), in which GE is portrayed as a latter-day Joan of Arc fighting the good fight of American entrepreneurship overseas, bringing electricity to one Japanese town. In the ad, GE breaks through the cabalism of foreign language, bureaucracy, and unethical rules in Japan to procure the goal of the big sell. The American nation can rest in peace as the Japanese nation succumbs to superior American technology.

Corporate advertising embraces the disparate elements of American society, drawing them into its infinitely broad umbrella of corporate citi-

zenship. Here again, in schooling, too, there is a tendency to sample the cultural form of different groups for the broader goal of preserving the Eurocentric core of the curriculum and inoculating the national ethos from the threat of alterity. Hence, synoptic treatments in the school curriculum of slavery, women's struggle for the right to vote, and American relations to Third World countries such as Panama and Grenada all serve to articulate these powerful subaltern historical and contemporaneous developments to the expansive web of benevolent actions of the nation-state. As a ressentiment discourse, then, the discourse of nation helps to identify and mark multiplicity and difference in order to contain these dynamic sites of alterity. Recall here Ruth Vinz's critique of the shopping mall treatment of Native American history in the multicultural school curriculum, discussed in Chapter 4.

Third, there is *the discourse of popular memory and popular history*. This discourse suffuses the nostalgic films of the last decade or so. Films such as *Dances with Wolves* (1990), *Bonfire of the Vanities* (1990), *Grand Canyon* (1993), *Falling Down* (1993), *Forrest Gump* (1994), *A Time to Kill* (1996), *The Fan* (1997), *Armageddon* (1998), and *Saving Private Ryan* (1998) foreground a white middle-class protagonist who appropriates the subject position of the persecuted social victim at the mercy of myriad forces—from "wild" black youth in Los Angeles (in *Grand Canyon*), to Asian store owners who do not speak English well (in *Falling Down*), to a black baseball player, living the too-good life in a moment of corporate downsizing (in *The Fan*). All hearken back to the "good old days" when the rules were few and exceedingly simple for the now-persecuted white middle class.

The struggle over memory conducted in popular culture is also enjoined within the curriculum and in education generally. While the textbook industry has been scrupulous in its preservation of a hierarchy of knowledges in school history books, pro-Eurocentric groups lead by the likes of Lynne Cheney, William Bennett, et al. have seen it as their goal to preserve "Western civilization," dominant military history, and a heroic "big man" view of the past from contamination of alternative accounting. The ressentiment discourse of popular memory and popular history rearticulates victim status and an associated sense of threat and vulnerability to a hegemonic political rationality that maintains that the dominant core of the curriculum, indeed the dominant core of society, is encircled and must be preserved from the contamination of competing narratives of marginalized groups—indigenous minorities or immigrants.

AGAINST "DISCIPLINED PEDAGOGIES"

As we have discussed more fully elsewhere, we see current work in multi-culturalism as a part of this larger project of ressentiment and a key site where the logics of containment are registering on school life today (McCarthy & Dimitriadis, 2000). Indeed, multicultural education has become the new metadiscipline that is most often deployed to address the current eruption of difference and plurality in social life now invading the school. It has become a set of propositions about identity, knowledge, power, and change in education, a kind of normal science, which attempts to "discipline" difference rather than be transformed by it. Multiculturalism has become a discourse of power that attempts to manage the extraordinary tensions and contradictions of modern life that have overtaken educational institutions. Multiculturalism has succeeded in preserving to the point of petrification its central object: "culture."

Within the managerial language of the university and in schooling, culture has become a useful discourse of containment in which particular groups are granted their nationalist histories, their knowledges, and alas, their experts. Cultural competence then becomes powerfully deployed to blunt the pain of resource scarcity and to inoculate the school's dominant knowledge paradigms from the daylight of subjugated knowledges and practices. As evidence of this defensive strategy, administrative multi-culturalists have steadfastly ignored all radical discourses on culture, including the critical discourses emerging out of postcolonial aesthetics.

Postcolonialism, as we demonstrated throughout, offers educators a way to think beyond multiculturalism's logics of containment, to more radical reassessments of constructs such as "culture" and binaries such as "here–there." Yet we see potential dangers here as well. As Stuart Hall (1996) suggests, "the 'post-colonial' has been most fully developed by literary scholars, who have been reluctant to make the break across disci-plinary (even post-disciplinary) lines" and explore other kinds of questions, including economic ones (p. 258). Clearly, there is the danger of circumscribing the kinds of questions that we can ask through "the postcolonial," by too clearly delimiting its parameters too early on. We see the potential encroachments of disciplines and disciplinary logics here as well.

Much of the artwork and criticism to which this book is devoted has no clear academic home. The neat separation between the humanities and the social sciences, for example, is completely obliterated in the work of Toni Morrison or James Baldwin. As we have argued elsewhere,

Baldwin offers a powerful model for qualitative research in his use of autobiography to register complex social and cultural "hieroglyphics" (Dimitriadis & McCarthy, 2000). Morrison, in turn, has repeatedly stressed that too often black literature is read simply as sociological treatise. She notes, "Black literature is taught as sociology, as tolerance, not as a serious, rigorous art form" (quoted in Taylor-Guthrie, 1994, p. 258). Yet it would be a mistake to suggest that Morrison is an advocate of "art for art's sake." The distinction, quite simply, has never been relevant for her. She says, to echo an earlier chapter,

> It takes some effort to keep a family together, a neighborhood together. So since that is the case, the old stories don't work anymore and songs don't work anymore, that folk art that kept us alive. So now I think novels are important because they're socially responsible. (p. 183)

We find in artists like Morrison a powerful, compelling human vision that cannot be contained in ready-made disciplinary confines. Clear demarcations between aesthetic form and political responsibility have no significance here. Hence, the three motifs that draw together the work in this book—*counterhegemonic representation*, *double or triple coding*, and *emancipatory or utopic visions*—underscore the insistence in postcolonial aesthetics on the inextricable link of art to social and political contexts. As the Palestinian performance and installation artist Mona Hartoum insists, "every aspect of life is full of contradictions: some people think that aesthetics and politics don't mix but that is ridiculous" (quoted in Archer, Brett, & De Zegher, 1997, p. 20).

The educational challenge of postcolonial thinkers, artists, and critics is fundamental here. Their concerns compel us to rethink the nature of knowledge stratification, cultural sampling, and the relationship of pedagogy to critical, politically applied work in more constitutive ways. These artists' visions can provide sustenance as we attempt to create spaces for radical work in institutions increasingly co-opted by atomized visions of who and what we are.

POSTCOLONIAL AESTHETICS AND NEW MILLENNIUM CHALLENGES FOR EDUCATORS

We have focused, of course, on school life throughout. But, following Baldwin, James, and the other artists discussed in this book, we see a

broader range of roles possible for critical educators today, both in terms of the educative sites we occupy and the texts we use. Increasingly, we see exciting possibilities for educators engaging with institutions that extend beyond the traditional sites toward, for example, community centers, churches, and other kinds of public spaces and spheres (Weis & Fine, 2000). We also have the opportunity to engage with "the popular" in an era in which the media have come to centrally occupy the interests and lives of young people (Dimitriadis, 2001). An increasingly wider range of sites and texts becomes relevant in our contemporary pedagogical struggle, sites and texts that fill a space largely abdicated by the narrow concerns of educational researchers and policymakers alike. Indeed, terms such as *education, pedagogy,* and *the curriculum* are more and more up for grabs as we enter this new millennium.

But the challenge for educators goes further than this. The great task of teachers and educators as we enter the 21st century is to address pedagogically the radical reconfiguration of educational and social life brought on by the proliferation of multiplicity and difference. As Harris suggests, we must find the "subtle links" of affiliation between self and other, acknowledging the relationship between our insistent particularity and the interdependence and multiplicity that define the modern world (1967, p. 28).

In the curriculum field in education there has been a dangerous tendency to simplify these matters. For example, current curriculum debates over multicultural education too easily oppose the literature, traditions, and culture associated with the Western canon to the new literatures of minority and indigenous groups, Western civilization to non-Western cultural practices, and so forth. It is assumed that since the dominant curriculum thrives on the marginalization of the culture of minorities, minority identities can be fully redeemed only by replacing the Western and Eurocentric bias of the curriculum with non-Western minority literature and cultural knowledge. The work of postcolonial artists such as Harris, Morrison, and Bennett directly challenges this binary opposition and the resulting curricular project of content addition and replacement that now guides many multicultural paradigms in universities and schools. Our argument in this book draws instead on the historical and genealogical work of Michael Bérubé (1992), Gerald Graff (1987), and John Guillory (1993), who all argue for a noncanonical or nontraditional reading of the canon.

In a strategy complementary to theirs, we have sought to uncover the deep philosophical preoccupations that animate Third World artists in their encounter with master narratives of the West. In the new postcolonial aesthetics a vast project of rewriting is well on the way—a project, we wish to suggest, of which teachers and students in American schools and universities cannot any longer remain blissfully ignorant. Such a project of rewriting urges us toward strategies of rereading: reading cultural forms and knowledges both intertextually and contextually; reading literature, for example, "contrapuntally," as Edward Said (1993) suggests. That is to say, we might now read Joseph Conrad's *Heart of Darkness* in the light of Chinua Achebe's *Things Fall Apart*; Daniel Defoe's *Robinson Crusoe* through the eyes of J. M. Coetzee's *Foe* or Derek Walcott's *Pantomime*; William Shakespeare's *The Tempest* under the microscope of George Lamming's *The Pleasures of Exile*; Virginia Woolf's *A Room of One's Own* in concert with Jamaica Kincaid's *Annie John*; and Fyodor Dostoyevsky's *Notes from the Underground* through the knowing gaze of Ralph Ellison's *Invisible Man*.

We might in a similar manner reread Van Gogh's tortured paintings through the new aesthetic prism offered by Bennett's *The Outsider* or Roche-Rabell's *Poor Devil*. Further, we might read *Poor Devil* against Toni Morrison's novel *The Bluest Eye* (1972) or reflect on popular world music through C. L. R. James's international critical oeuvre. We must ultimately work to make linkages across the boundaries of music, painting, writing, and other art forms—and we must, as well, rethink the relationship of aesthetics to the broad range of contemporary social issues as these postcolonial artists have done.

We urge educators to begin to let the sensibility of a complex, interdependent world into the lives of students. We need to challenge the tragic images of mainstream television and textbooks and to expand our own sensibilities in America by embracing the world. Postcolonial aesthetics, it seems to us, work through a different set of propositions about human actors than the ones that seem to have taken hold in education lately: the origins claims, the Eurocentric claims, the foundational claims of an essential and indispensable core of knowledge that our children need to know, and so forth—all appeals to ressentiment. These are all tired formulas that have led to the loss of genuine autonomy and creativity in the educational field.

CONCLUSION

This moment is replete with both possibility and danger. Our period of intense globalization and the rise of multinational capital has played a large part in ushering in the multicultural age—an age in which the empire has struck back, and first world exploitation of the Third World has so depressed the latter that there has been a steady stream of immigrants from the periphery seeking better futures in the metropolitan centers. With the rapid growth of minority populations in the United States, there is now a formidable cultural presence of diversity in virtually every sphere of American social life.

Indeed, if this is an era of the post, it is also an era of difference, which presents us with the challenge of living in a world of incompleteness, discontinuity, and multiplicity. This era requires us to generate a mythology of social interaction that goes beyond the model of ressentiment. It requires us to take seriously the Nietzschean critique of ressentiment as the process of identity formation that thrives on the negation of the other. We are challenged to embrace a politics that calls on the moral resources of all who are opposed to the emerging global formation of power.

To put this in more direct pedagogical and educational terms, we argue that the great task confronting teachers and educators as we move into the 21st century is to address the radical reconfiguration and cultural rearticulation taking place in educational and social life—a set of processes underscored at the beginning of this book. The dominant response to this proliferation of difference and multiplicity, again, has been to suppress the implications for rethinking the ethical, political, and epistemological basis of education by imposing a program of homogeny and deploying the divide and conquer tactics of ressentiment. To a large extent, such a hegemonic approach is deeply informed by the long history of intellectual and academic colonialism in American educational institutions, where Anglos define the history and other groups serve as the objects of such definitions. Within this framework, curriculum works to divest youth of their identities and intellectual autonomy and to impede prospects for a fully invested, more critical form of multiculturalism. This hegemonic approach constitutes a top-down project that attempts to hold the Eurocentric and establishment core of the curriculum in place, inoculating it by simply adding on selected, nonconflictual items from

the culture and experiences of minority and subaltern groups. This, as we have noted, has defined much of the thinking and practice of institutionalized multicultural education.

But this approach to knowledge and culture is also to be found in the curricular formulations of some minority school critics as well. Cultural monologists within subaltern groups argue for the simple inversion of the Eurocentric dominance of the curriculum. They maintain that the cultural knowledges and experiences of their specifically embattled minority group—be it African American, Chicana/o, Asian American, or Native American—should be foregrounded in a manner that would effectively displace the Eurocentric core of the curriculum, replacing it with a specific minority program of affirmation of cultural heritage.

This ideal of community that Eurocentric and minority curricular monologists envision presumes a singular meta-subject at the heart of the curriculum. This desire for the culturally guaranteed community relies on the same desire for monochromatic social wholeness and identification that underlies racism and ethnic chauvinism. This program of community affiliation may help reproduce a sameness and a reassuring familiarity to curricular knowledge, but this occurs at the price of the suppression of the dynamism of the difference and alterity that excluded or marginalized knowledges and subjectivities bring to any educational setting.

By contrast, the approach that postcolonial aesthetics offers to curriculum change is based on the recognition of the plurality of subject positions operating at any given moment in the educational and cultural context. This approach seeks to integrate the logics of globalization into curriculum and educational frameworks by openly, but creatively, addressing the tensions and contradictions associated with the past, present, and future interests, needs, and desires of the full plurality of educational actors. It is recognized here that modern school subjects are better comprehended in their historical and contemporaneous heterogeneity than through structurally imposed categories or binary positions. A curriculum informed by postcolonial aesthetics would therefore reject outright all imperializing forms of the self/other binary as they are expressed in contemporary schooling. Instead, as the work of writers such as Morrison and Harris and painters such as Roche-Rabell and Bennett suggests, we must strive for the goal of the creative fusion and vitalization of those mini-narratives that every unique individual—every student and every teacher—brings to a human encounter such as the pedagogical setting, exploring the full richness of their particularities. In so doing we

directly challenge the tendency of dominant curriculum practices to fix student creativity and identities into structurally enforced categories.

Thinking in postcolonial terms about the topic of difference and multiplicity in education means thinking relationally and contextually. It means bringing back into educational discourses all those tensions and contradictions that we tend to suppress as we process experience and history into curricular knowledge (Pinar, 2000). It means abandoning the auratic status of concepts such as culture and identity for a recognition of the vital porosity that exists between and among human groups in the modern world—as the postcolonial artists whom we have foregrounded in this book have so persuasively shown. It means, ultimately, thinking across ressentiment oppositions, disciplinary boundaries, and the insulation of knowledge.

Our age of difference thus poses new, tactical, and strategic challenges to critical and subaltern intellectuals operating in educational institutions and within the theater of popular culture, the broad realm of the public sphere. A first condition must be the recognition that our differences of race, gender, and nation are merely the starting points for new solidarities and new alliances, not the terminal stations for depositing our agency and identities or extinguishing hope and possibility. Such a strategy of alliance might help us to better understand the issue of diversity in schooling and its linkages to the problems of social integration and public policy in modern life. A strategy of alliance might allow us to produce new anti-disciplinary pedagogies that will respond to this fraught and exceedingly fragile moment of globalized, postcolonial life.

References

Adorno, T. (1980). *Prisms*. Cambridge: MIT Press.

Afzal-Khan, F., & Seshadri-Crooks, K. (Eds.). (2000). *The pre-occupation of postcolonial studies*. Durham, NC: Duke University Press.

Allende, I. (1985). *The house of the spirits* (M. Bogin, Trans.). New York: A. A. Knopf.

Appadurai, A. (1996). *Modernity at large: Cultural dimensions of globalization*. Minneapolis: University of Minnesota Press.

Appadurai, A. (2000). Grassroots globalization and the research imagination. *Public Culture, 12*(1), 1–19.

Apple, M. (1993). *Official knowledge: Democratic education in a conservative age*. New York: Routledge.

Archer, M., Brett, G., & De Zegher, C. (1997). *Mona Hatoum*. London: Phaidon.

Arenas, R. (1987). *Graveyard of the angels*. New York: Avon.

Armah, A. (1968). *The beautyful ones are not yet born*. Boston: Houghton Mifflin.

Asante, M. (1993). *Malcolm X as cultural hero, and other Afrocentric essays*. Trenton, NJ: Africa World Press.

Asante, M. (1997). *Kemet, Afrocentricity and knowledge*. Trenton, NJ: Africa World Press.

Baer, W. (Ed.). (1996). *Conversations with Derek Walcott*. Jackson: University Press of Mississippi.

Bakhtin, M. (1984). *Problems of Dostoyevsky's poetics*. Minneapolis: University of Minnesota Press.

Baldwin, J. (1955a). *Notes of a native son*. Boston: Beacon Press.

Baldwin, J. (1955b). Everybody's protest novel. In *Notes of a native son* (pp. 13–23). Boston: Beacon Press.

Baldwin, J. (1955c). Many thousands gone. In *Notes of a native son* (pp. 24–45). Boston: Beacon Press.

Baldwin, J. (1955d). Stranger in the village. In *Notes of a native son* (pp. 159–175). Boston: Beacon Press.

Baldwin, J. (1956). *Giovanni's room*. New York: Dell.

Baldwin, J. (1962). *Another country*. New York: Dial Press.

Baldwin, J. (1963). *The fire next time*. New York: Dial Press.

Baldwin, J. (1964). *Blues for Mister Charlie*. New York: Dell.

Baldwin, J. (1968). *Tell me how long the train's been gone*. New York: Vintage.

Baldwin, J. (1972). *No name in the street*. New York: Dell.

Baldwin, J. (1973). *One day when I was lost*. New York: Dial Press.

Baldwin, J. (1976). *The devil finds work*. New York: Dial Press.

Baldwin, J. (1983, November). *Fifth Richard Wright lecture*. Yale University, New Haven, CT.

Baldwin, J. (1985a). *Jimmy's blues*. New York: St. Martin's Press.

Baldwin, J. (1985b). The price of the ticket. In *The price of the ticket: Collected nonfiction 1948–1985* (pp. ix–xx). New York: St. Martin's Press.

Baldwin, J. (1985c). They can't turn back. In *The price of the ticket: Collected nonfiction 1948–1985* (pp. 215–228). New York: St. Martin's Press. (Original work published 1960.)

Baldwin, J. (1988). A talk to teachers. In R. Simonson & S. Walker (Eds.), *The Graywolf annual: Multi-cultural literacy* (pp. 3–12). Saint Paul: Graywolf Press.

Becker, H. (1982). *Art worlds*. Berkeley: University of California Press.

Belsey, C. (1980). *Critical practice*. London: Methuen.

Benjamin, W. (1968). The work of art in the age of mechanical reproduction. In *Illuminations: Essays and reflections* (H. Zohn, Trans.) (pp. 217–242). New York: Schocken Books.

Benjamin, W. (1977). *The origin of German tragic drama* (J. Osbourne, Trans.). London: New Left Books.

Bennett, T. (1995). *The birth of the museum*. New York: Routledge.

Bennett, W. (1994). *The book of virtues*. New York: Simon and Schuster.

Berger, J. (1972). *Ways of seeing*. London: Penguin.

Berlinerblau, J. (1999). *Heresy in the university: The Black Athena controversy and the responsibilities of American intellectuals*. Piscataway, NJ: Rutgers University Press.

Bernal, M. (1989). *Black Athena: The Afroasiatic roots of classical civilization*. Piscataway, NJ: Rutgers University Press.

Bérubé, M. (1992). *Marginal forces/cultural centers: Tolson, Pynchon, and the politics of the canon*. Ithaca, NY: Cornell University Press.

Bhabha, H. K. (1994). *The location of culture: Literature related to politics*. London: Routledge.

Bizzell, P., & Herzberg, B. (1996). *Negotiating difference: Cultural case studies for composition*. Boston: Bedford Books of St. Martin's Press.

Chambers, I. (1996). Signs of silence, lines of listening. In I. Chambers & L. Curt (Eds.), *The post-colonial question: Common skies, divided horizons* (pp. 47–62). London: Routledge.

Chernoff, J. (1979). *African rhythm and African sensibility: Aesthetics and social action in African musical idioms.* Chicago: University of Chicago Press.

Clifford, J. (1997). *Routes: Travel and translation in the late twentieth century.* Cambridge, MA: Harvard University Press.

Cornbleth, C. (1990). Reforming curriculum reform. In L. Weis, C. Cornbleth, K. Keichner, & M. Apple, *Curriculum for tomorrow's schools* (pp. 1–31). Buffalo, NY: Graduate School of Education Publications (State University of New York at Buffalo).

Cornbleth, C., & Waugh, D. (1995). *The great speckled bird: Multicultural politics and educational policymaking.* New York: St. Martin's Press.

Crouch, S. (1990). *Notes of a hanging judge: Essays and reviews 1979–1989.* New York: Oxford.

Dash, M. (1990). *Ex-centric spaces: Marronnage and metissage in the Caribbean imagination.* Unpublished paper presented at "Plantation Societies" conference, Louisiana State University.

Dent, G. (1992). Black pleasure, black joy: An introduction. In G. Dent (Ed.), *Black popular culture* (pp. 1–20). Seattle: Bay Press.

Devine, J. (1996). *Maximum security: The culture of violence in inner-city schools.* Chicago: University of Chicago Press.

Dimitriadis, G. (1999). Hip hop to rap: Some implications of an historically situated approach to performance. *Text and Performance Quarterly, 19*(4), 355–369.

Dimitriadis, G. (2001). *Performing identity/performing culture: Hip hop as text, pedagogy, and lived practice.* New York: Peter Lang.

Dimitriadis, G., & McCarthy, C. (2000). Stranger in the village: James Baldwin, popular culture, and the ties that bind. *Qualitative Inquiry, 6*(2), 171–187.

Drake, S. (1989). Language and revolutionary hope. In M. Gilkes (Ed.), *The literate imagination* (pp. 65–81). London: Macmillan.

Ellison, R. (1972). *Shadow and act.* New York: Vintage.

Feld, S. (1994). From schizophonia to schismogeneis: On the discourses and commodification of "world music" and "world beat." In C. Keil & S. Feld (Eds.), *Music grooves: Essays and dialogues* (pp. 257–289). Chicago: University of Chicago Press.

Flores, J. (1993). *Divided borders: Essays on Puerto Rican identity.* Houston: Arte Publico Press.

Foucault, M. (1988). *The care of the self: The history of sexuality, Volume III* (R. Hurley, Trans.). New York: Vintage.

Freire, P. (1970). *Pedagogy of the oppressed.* New York: Continuum.

Frith, S. (1996). *Performance rites.* Cambridge: Harvard University Press.

Gates, H. L. (1988). *The signifying monkey: A theory of Afro American literary criticism.* New York: Oxford.

Gilbert, J., & Pearson, E. (1999). *Discographies: Dance music, culture and the politics of sound.* London: Routledge.

Gilroy, P. (1988–89). Cruciality and the frog's perspective. *Third Text, 5,* 33–44.

Gilroy, P. (1993). *The black Atlantic.* Cambridge, MA: Harvard University Press.

Giroux, H. (1996). *Fugitive cultures: Race, violence, and youth.* New York: Routledge.

Gonzalez, J. (1993). *Puerto Rico: The four-storied country and other essays.* Princeton and New York: Markus Wiener.

Gordon, I. (1993). *American history review text.* New York: Amsco.

Graff, G. (1987). *Professing literature: An institutional history.* Chicago: University of Chicago Press.

Gray, P. (1998, January 19). Paradise Found; The Nobel Prize changed Toni Morrison's life but not her art, as her new novel proves. *Time,* p. 62.

Greene, M. (1995). *Releasing the imagination: Essays on education, the arts, and social change.* San Francisco: Jossey-Bass.

Guillory, J. (1993). *Cultural capital: The problem of literary canon formation.* Chicago: University of Chicago Press.

Hall, S. (1996). When was "the post-colonial"? Thinking at the limit. In I. Chambers & L. Curt (Eds.), *The post-colonial question: Common skies, divided horizons* (pp. 242–260). London: Routledge.

Harris, W. (1960). *The palace of the peacock.* London: Faber.

Harris, W. (1961). *The far journey of Oudin.* London: Faber.

Harris, W. (1962). *The whole armour.* London: Faber.

Harris, W. (1963). *The secret ladder.* London: Faber.

Harris, W. (1967). *Tradition, the writer, and society: Critical essays.* London: New Beacon.

Harris, W. (1975). *Companions of the day and night.* London: Faber.

Harris, W. (1983). *The womb of space.* Westport, CT: Greenwood Press.

Harris, W. (1985a). *Carnival.* London: Faber.

Harris, W. (1985b). *The Guyana quartet.* London: Faber.

Harris, W. (1989). Literacy and the imagination. In M. Gilkes (Ed.), *The literate imagination* (pp. 13–30). London: MacMillan.

Hatoum, M. (2000). *Measures of distance.* London: London Tate Modern.

Head, B. (1968). *When rain clouds gather.* New York: Simon & Schuster.

Head, B. (1974). *A question of power.* London: Heinemann Educational.

Held, D. (1980). *Introduction to critical theory.* Berkeley: University of California Press.

Henry, P. (2000). *Caliban's reason: Introducing Afro-Caribbean philosophy.* New York: Routledge.

Hoban, P. (1998). *Basquiat: A quick killing in art.* New York: Viking.

Hobbs, R. (1996). *Arnaldo Roche-Rabell: The Uncommonwealth*. Seattle: University of Washington Press.

hooks, b. (1994). *Teaching to transgress: Education as the practice of freedom*. London: Routledge.

James, C. L. R. (1936). *Minty alley*. London: Secker & Warburg.

James, C. L. R. (1963). *Beyond a boundary*. London: Stanley Paul.

James, C. L. R. (1966, October 20). James Baldwin's attack on Native Son. *Sunday Guardian*, pp. 7+.

James, C. L. R. (1980a). *The future in the present*. London: Allison & Busby.

James, C. L. R. (1980b). *Spheres of existence*. London: Allison & Busby.

James, C. L. R. (1992a). The Black Jacobians. In A. Grimshaw (Ed.), *The C. L. R. James Reader* (pp. 67–111). Oxford, UK: Blackwell. (Original work published 1936).

James, C. L. R. (1992b). La divina pastora. In A. Grimshaw (Ed.), *The C. L. R. James Reader* (pp. 25–28). Oxford, UK: Blackwell. (Original work published 1927).

James, C. L. R. (1992c). Triumph. In A. Grimshaw (Ed.), *The C. L. R. James Reader* (pp. 29–40). Oxford, UK: Blackwell. (Original work published 1929).

James, C. L. R. (1992d). Three Black women: Toni Morrison, Alice Walker, Ntozake Shange. In A. Grimshaw (Ed.), *The C. L. R. James Reader* (pp. 411–417). Oxford, UK: Blackwell. (Original work published 1981).

James, C. L. R. (1992e). Picasso and Jackson Pollock. In A. Grimshaw (Ed.), *The C. L. R. James Reader* (pp. 405–410). Oxford, UK: Blackwell. (Original work published 1980).

James, C. L. R. (1993). *American civilization*. London: Blackwell.

James, C. L. R. (1996). *Special delivery: The letters of C. L. R. James to Constance Webb, 1939–1948*. Oxford, UK: Blackwell.

Jencks, C. (1996). *What is postmodernism?* London: Academy Editions.

Karenga, R. (1972). Black art: Mute matter given form and function. In A. Chapman (Ed.), *New Black voices: An anthology of contemporary Afro-American literature* (pp. 477–482). New York: Mentor.

Keil, C. (1994). Motion and feeling through music. In C. Keil & S. Feld (Eds.), *Music grooves* (pp. 53–76). Chicago: University of Chicago Press.

Keil, C. (1966). *Urban blues*. Chicago: University of Chicago Press.

Kellner, D. (1995). *Media cultures*. New York: Routledge.

Kothari, U. (2001). *Participatory development: Power, knowledge, and social control*. Unpublished manuscript, Institute of Development Policy and Management, The University of Manchester, UK.

Lamming, L. (1960). *Season of adventure*. London: Allison and Busby.

Lamming, G. (1971). *Natives of my person*. London: Allison and Busby.

Lather, P. (1997). Drawing the lines at angels: Working the ruins of feminist

ethnography. *International Journal of Qualitative Studies in Education,*
10(3), 285–304.

Lave, J., & Wenger, W. (1991). *Situated learning: Legitimate peripheral partici-*
pation. Cambridge, UK: Cambridge University Press.

Lefkowitz, M. (1997). *Not out of Africa: How Afrocentrism became an excuse to*
teach myth as history. New York: Basic Books.

Lincoln, Y., & Denzin, N. (2000). The seventh moment: Out of the past. In
N. Denzin & Y. Lincoln (Eds.), *Handbook of qualitative research* (2nd ed.)
(pp. 1047–1065). Thousand Oaks, CA: Sage Publications.

Lingard, B., & Rizvi, F. (1994). (Re)membering, (dis)membering "Aboriginal-
ity" and the art of Gordon Bennett. *Third Text, 26,* 75–89.

Lipsitz, G. (1990). *Time passages: Collective memory and American popular cul-*
ture. Minneapolis, MN: University of Minnesota Press.

Lipsitz, G. (1994). *Dangerous crossroads: Popular music, postmodernism, and the*
poetics of place. New York: Verso.

Lyotard, F. (1984). *The postmodern condition: A report on knowledge* (G. Ben-
nington & B. Massumi, Trans.). Minneapolis, MN: University of Minne-
sota Press.

McCarthy, C., & Crichlow, W. (Eds.). (1993). *Race, identity, and representa-*
tion in education. London: Routledge.

McCarthy, C., & Dimitriadis, G. (2000). Globalizing pedagogies: Power, re-
sentment, and the re-narration of difference. *World Studies in Education,*
1(1), 23–39.

McClary, S. (1994). Same as it ever was. In A. Ross & T. Rose (Eds.), *Micro-*
phone fiends: Youth music and youth culture (pp. 29–40). New York:
Routledge, 1994.

McDougall, R. (1989). Native capacity, blocked psyche: "Carnival" and "Capri-
cornia." In M. Gilkes (Ed.), *The literate imagination* (pp. 152–171). Lon-
don: Macmillan.

McGee, P. (1993). Decolonization and the curriculum of English. In C. McCar-
thy & W. Crichlow (Eds.), *Race, identity, and representation in education*
(pp. 280–288). New York: Routledge.

McGuigan, J. (1992). *Cultural populism.* London: Routledge.

McLean, I., & Bennett, G. (1996). *The art of Gordon Bennett.* Roseville East,
New South Wales, Australia: Craftsman House.

Marshall, R. (1995). *Jean-Michel Basquiat.* New York: Whitney/Abrams.

Masterman, L. (1990). *Teaching the media.* London: Routledge.

Min, Y. S. (1997). Bridge of no return. In *Krannert Art Museum Fall 1997*
catalogue (p. 11). Champaign, IL: Krannert Art Museum.

Mingus, C. (1971). *Beneath the underdog.* New York: Vintage.

Morrison, T. (1972). *The bluest eye.* New York: Washington Square Press.

Morrison, T. (1974). *Sula.* New York: Knopf.

Morrison, T. (1977). *Song of Solomon*. New York: Signet.

Morrison, T. (1981). *Tar baby*. New York: Knopf.

Morrison, T. (1987). *Beloved*. New York: Knopf.

Morrison, T. (1992). *Jazz*. New York: Knopf.

Morrison, T. (1998). *Paradise*. New York: Knopf.

Ngũgĩ wa Thiang'o. (1982). *Devil on the cross*. London: Heinemann.

Nietzsche, F. (1967). *On the genealogy of morals*. (W. Kaufman, Trans.). New York: Vintage.

Okigbo, C. (1971). *Labyrinths*. London: Heinemann.

Ousby, I. (1988). *The Cambridge guide to literature in English*. Cambridge, UK: Cambridge University Press.

Pinar, W. (2000). *Toward the internationalization of curriculum studies*. Unpublished paper presented at the Internationalization of Curriculum Studies conference, Louisiana State University, Baton Rouge.

Pollock, D. (Ed.). (1998). *Exceptional spaces: Essays in performance and history*. Chapel Hill: University of North Carolina Press.

Popkewitz, T. (1998). *Struggling for the soul: The politics of schooling and the construction of the teacher*. New York: Teachers College Press.

Quayson, A. (2000). *Postcolonialism: Theory, practice, or process?* Malden, MA: Blackwell Publishers.

Reynolds, S. (1999). *Generation ecstasy: Into the world of techno and rave culture*. New York: Routledge.

Rico, B., & Mano, S. (1991). *American mosaic: Multicultural readings in context*. Boston: Houghton Mifflin.

Ritsma, N. (2000). *Mona Hatoum*. Urbana, IL: unpublished paper, Department of Art History, University of Illinois.

Roberts, P. (1989). *U.S. history review text*. New York: Amsco.

Roediger, D. (1999). *Black on white: Black writers on what it means to be white*. New York: Schocken Books.

Rosaldo, R. (1993). *Culture and truth: The remaking of social analysis*. Boston: Beacon Press.

Rose, T. (1994). *Black noise: Rap music and black music in contemporary America*. Hanover, NH: Wesleyan University Press.

Said, E. (1993). *Culture and imperialism*. New York: Knopf.

Said, E. (1999). *Out of place: A memoir*. New York: Knopf.

Schmidt, J. (2000). *Disciplined minds: A critical look at salaried professionals and the soul-battering system that shapes their lives*. New York: Roman and Littlefield.

Shange, N. (1983). Bocas: A daughter's geography. In N. Shange, *A daughter's geography* (pp. 21–23). New York: St. Martin's Press.

Shohat, E. (1992). Notes on the "post-colonial." *Social Text, 31/32*, 99–113.

Small, C. (1977). *Music, society, education: A radical examination of the pro-*

phetic function of music in Western, Eastern, and African cultures with its impact on society and its uses in education. London: John Calder.

Small, C. (1987). *Music of the common tongue: Survival and celebration in Afro-American music*. London: John Calder.

Soyinka, W. (1965). *The interpreters*. London: Andre Deutsch.

Soyinka, W. (1974). *Season of anomy*. New York: Third Press.

Spivak, G. (1988). Can the subaltern speak? In C. Nelson & L. Grossberg (Eds.), *Marxism and the interpretation of culture* (pp. 271–313). Chicago: University of Illinois Press.

Stallybrass, P., & White, A. (1986). *The politics and poetics of transgression*. Ithaca, NY: Cornell.

Taussig, M. (1980). *The devil and commodity fetishism in South America*. Chapel Hill: University of North Carolina.

Taylor, T. (1997). *Global pop: World music, world markets*. New York: Routledge.

Taylor-Guthrie, D. (1994). *Conversations with Toni Morrison*. Jackson: University Press of Mississippi.

Theberge, P. (1998). *Any sound you can imagine: Making music/consuming technology*. Hanover, NH: Wesleyan University Press.

Thompson, R. F. (1995). Royalty, heroism, and the streets: The art of Jean Basquiat. In R. Marshall (Ed.), *Jean-Michel Basquiat* (pp. 28–42). New York: Whitney/Abrams.

Tomlinson, J. (1999). *Globalization and culture*. Chicago: University of Chicago Press.

Vinz, R. (1999). Learning from the blues: Beyond essentialist readings of cultural texts. In C. McCarthy et al. (Eds.), *Sound identities* (pp. 391–427). New York: Peter Lang.

Walcott, D. (1970). *Dream on monkey mountain and other plays*. New York: Farrar, Strauss and Giroux.

Walcott, D. (1990). *Omeros*. New York: Farrar, Straus, & Giroux.

Walcott, D. (1993). *The Antilles: Fragments of epic memory*. New York: Farrar, Strauss and Giroux.

Walcott, D. (1995). The muse of history. In B. Ashcroft, G. Griffiths, & H. Tiffin (Eds.), *The post-colonial studies reader* (pp. 370–374). London: Routledge.

Walcott, D. (2000). *Tiepolo's hound*. London: Faber and Faber.

Walser, R. (1993). *Running with the devil: Power, gender, and madness in heavy metal music*. Hanover, NH: Wesleyan University Press.

Webb, B. (1992). *Myth and history in Caribbean fiction: Alejo Carpentier, Wilson Harris, and Edouard Glissant*. Amherst: The University of Massachusetts Press.

Weis, L., & Fine, M. (Eds.). (2000). *Construction sites: Excavating race, class, and gender among urban youth.* New York: Teachers College Press.

West, C. (1992). Nihilism in black America. In G. Dent (Ed.), *Black popular culture* (pp. 37–47). Seattle: Bay Press.

Will, G. (1989, December 18). Eurocentricity and the school curricula. *Baton Rouge Morning Advocate*, 3.

Index

About the Authors

Greg Dimitriadis is Assistant Professor of Sociology of Education in the Department of Educational Leadership and Policy at the University at Buffalo, The State University of New York. His work on popular culture, education, and the lives of urban youth has appeared in numerous books and journals. He is the author of *Performing Identity/Performing Culture: Hip Hop as Text, Pedagogy, and Lived Practice.*

 Cameron McCarthy is Research Professor and University Scholar at the University of Illinois's Institute of Communications Research. His previous works include *The Uses of Culture: Education and the Limits of Ethnic Affiliation* and *Race, Identity, and Representation in Education.*